IMAGES
of America

WAXAHACHIE

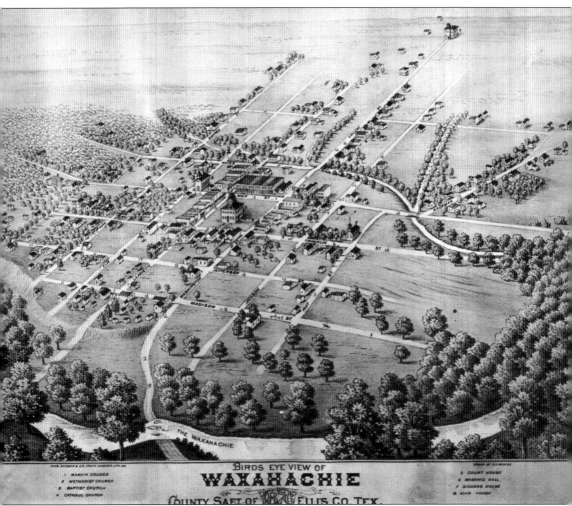

BIRDS EYE VIEW OF

WAXAHACHIE

COUNTY SEAT OF 1876 ELLIS CO. TEX.

In 1876, when this bird's-eye view of Waxahachie was drawn, the railroad had not yet reached the county seat of Ellis County. The town's center of commerce was building up within the blocks surrounding the courthouse, as seen in the image. Homes and churches were also being built, and Marvin College, one of the earliest educational institutions of the area, is pictured in the upper right-hand portion of the map. (Courtesy of Ellis County Museum.)

ON THE COVER: James P. Kennedy, one of the founding settlers, arrived in Waxahachie before the county was formed in 1849. He founded and operated the J. P. Kennedy Carriage Shop. He married Fannie Ellis, daughter of J. H. Ellis, who ran a boardinghouse at Franklin and College Streets. They raised their family at their home, which was just a few blocks west of the courthouse square on Franklin Street. Pictured are many of his grandchildren on December 26, 1899. (Courtesy of Ellis County Museum.)

IMAGES
of America

WAXAHACHIE

Kathryn E. Eriksen, Laurie J. Wilson,
and the Waxahachie Journal

ARCADIA
PUBLISHING

Published by Arcadia Publishing
Charleston SC, Chicago IL, Portsmouth NH, San Francisco CA

Printed in the United States of America

Library of Congress Control Number: 2009923821

For all general information contact Arcadia Publishing at:
Telephone 843-853-2070
Fax 843-853-0044
E-mail sales@arcadiapublishing.com
For customer service and orders:
Toll-Free 1-888-313-2665

Visit us on the Internet at www.arcadiapublishing.com

This book is dedicated to the Ellis County Museum, its curator, Mr. Shannon Simpson, and to all of those people who ensure that history is preserved for later generations to treasure.

CONTENTS

ACKNOWLEDGMENTS

This book reflects the continuing dedication of the Ellis County Museum to preserve and protect the historical documents, photographs, memorabilia, and treasured artifacts of Ellis County for future generations.

Many different individuals contributed to this book with their personal family photographs, their knowledge and love of history, and their loving support. We owe much gratitude and thanks to Ann Allen, Sam Estey of the Sims Library of Waxahachie, Perry Giles, Julie Hinz, Robbie Davis Howard, Ray Lowry of the Ennis Public Library, Peggy Spalding, and Fr. Terry Reisner of St. Paul's Episcopal Church. Much of our research would not have been complete without the historical information gleaned from the Waxahachie *Daily Light*.

We owe a debt of gratitude to Shannon Simpson of the Ellis County Museum. His patience and knowledge have made this book what it is. It could not have been done without him.

We want to express our gratitude and appreciation to our editor at Arcadia Publishing, Luke Cunningham, who has been a steadfast supporter of this book. Luke was our cheerleader and helped us cross the finish line—on time!

Finally, we thank our families for their loving support, encouragement, and understanding. We could not have completed this book without you!

INTRODUCTION

The story of Waxahachie and its development begins with her unusual name. *Waxahachie* is the name that the local Indians gave to the creek that runs south of downtown. Translated, it literally means "cow creek" or "buffalo creek." Perhaps a more fitting name would have been Cotton Creek, since that crop played such an important role in the growth and development of the community.

From her humble beginnings as a farming settlement to the nation's largest cotton producing county and then to a modern city of 30,000, Waxahachie has a rich and colorful history. The town was formed in 1850 and designated as the county seat for Ellis County. E. W. Rogers was one of the first settlers in the area, and his original homestead became the primary orientation point for the new town. Growth during the early years was slow, mainly because the frontier conditions were harsh, and the density of development practically nonexistent. The 1850 census only showed 989 citizens living in the entire county.

But the seeds of growth were planted, and they lay dormant, waiting for the optimal conditions to sprout. Waxahachie was the county seat for Ellis County, which proved to be a determining factor in her growth and influence. A simple log building that was moved from Dallas County to the public square near E. W. Rogers' homestead became the first courthouse of the new county. It quickly became the center of activity and spurred the development of retail businesses around it. A. B. Marchbanks is believed to be the new town's first merchant.

Growth was slow, and the local economy remained agriculturally based. According to the 1860 census, the most popular crops grown in the county were wheat, oats, corn, and sweet potatoes. Cattle formed another important component in the livelihood of the early settlers. But the one crop that would help catapult Waxahachie's growth, development, and population in the late 1800s was only grown in small quantities before and after the Civil War. The Agricultural Schedule of 1860 lists only 389 bales of cotton produced in Ellis County. Few recognized that the fertile soil in Ellis County was well suited to cotton, and fewer still could see past the obstacles of harvesting and shipping the cotton to more lucrative markets.

After the Civil War, Waxahachie enjoyed renewed prosperity and economic expansion. The downtown square was vibrant with people, and new residents to the area helped to diversify the local economy. J. W. Ferris and W. H. Getzendaner, two law partners, formed a small bank in 1868. Now known as Citizen's National Bank, it is considered one of the oldest banking institutions in North Texas. Other merchants opened their businesses on the courthouse square, including Aaron Tripett's mercantile store. Tripett later built an opulent home on Grand Avenue that remains one of the jewels of Waxahachie's collection of Victorian homes.

The new settlers also helped establish churches of various denominations, including Methodist, Presbyterian, Baptist, Catholic, and Episcopalian. The only 19th century church that remains standing is St. Paul's Episcopal Church. The cornerstone for the 70-seat church was first laid on April 16, 1887.

As the population grew, the need for schools became urgent. The first educational facility was located in the Waxahachie Masonic Lodge, erected in 1860. The building served as a meeting hall for the lodge members and was used as a school. It stood on Main Street, in the location that is now occupied by the Sims Library. Marvin College was established in 1870, and most students were from Waxahachie. Funded by the Methodist Episcopal Church, it was named for E. M. Marvin, who was bishop of the district. The school was located on the north side of town and was isolated from the community until residential development encompassed it.

As more people made Waxahachie their home, the basic elements of a thriving community were created. Schools, churches, businesses, and roadways were developed and expanded. The town was officially incorporated under state law in 1870, and in 1871, the cornerstone of a new county courthouse was laid. Downtown log or wood structures were replaced with stone or brick construction. Waxahachie was poised to flourish—it just needed one more critical element to fall into place, the railroad.

Rail service did not reach Waxahachie until 1879. The first tracks were built in the eastern part of the county by the Houston and Texas Central and helped create the town of Ennis. Business leaders and citizens of Waxahachie quickly realized the necessity of rail service to their town and formed the Waxahachie Tap Railroad to bring rail service to Waxahachie. Financial obstacles and mismanagement stalled the creation of a tap line, but it was eventually finished in September 1878 and ran just north of downtown. The Fort Worth and New Orleans Railroad came to Waxahachie in 1886, and its tracks were built farther north of downtown.

The railroad's impact on the growth and development of Waxahachie was profound and could be seen on many levels. The population swelled—from 1,354 in 1870 to 3,076 in 1880. Businesses grew and expanded because the railroad provided cheap transportation of goods in and out of the community. Commercial real estate development became active in the areas adjacent to the railroads. Railroad tracks were installed just south of downtown in 1891, and these tracks became the most popular means of transportation.

But it was the growth and production of cotton that benefited the most from the inexpensive transport provided by the railroads. Entire markets opened up to Ellis County cotton farmers, because cotton bales could be shipped in greater quantities, faster and cheaper, to distant parts of the country. Cotton-related businesses, such as warehouses, gins, and cotton yards sprung up near the rail lines. Lumberyards also became a viable part of the landscape because the rail brought building materials and supplies that were used in the growing community.

Cotton soon dominated the local economy. Ellis County became the largest cotton producing county in the entire country. The 1880 Agricultural Schedule indicated that 52,172 bales of cotton were ginned in Ellis County. By 1910, that figure had more than doubled to 106,384. Waxahachie was the hub for cotton ginning in Ellis County, and the Waxahachie Cotton Mills Company was created in 1899. Local residents raised most of the money for the construction of the cotton mill, which was located on 20 acres west of town and next to the railroad tracks. The facility opened in 1901, with 500 spindles and 150 looms. A large boardinghouse and 24 small frame homes were built for the textile workers. This area became known as Cotton Mill Village.

The prosperity enjoyed by the cotton farmers, gin owners, and other businesses related to cotton production could be seen in the many opulent homes that were constructed during the late 19th and early 20th century. Both the east and west ends of the community became popular locations for the elegant homes built by financially successful individuals. Large, impressive homes constructed in the Victorian style grace many of the streets of Waxahachie, and they remain standing today, a testament to the original owners' status. In 1889, local streetcar service began, which further spurred growth in outlying areas.

Local lumber companies and contractors provided the materials and labor to build these fine houses during this time period. Because the town did not have a resident architect, pattern book houses were quite popular. Pattern books provided the plans and specifications for various styles and sizes of homes. The most popular pattern book at that time was the book designed by George Barber, a Knoxville, Tennessee, architect, whose drawings were sold throughout the

country. The residence located at 209 Grand Avenue, built by H. W. Tripett, is a fine example of a Barber pattern house.

The prominence and status of Waxahachie during the late 19th and 20th centuries is also displayed in the public buildings that were constructed at that time. None is more important than the Ellis County Courthouse, which was completed in 1897 and located in the heart of downtown. Acclaimed architect James Riely Gordon of San Antonio designed the imposing Richardsonian Romanesque structure, which stands three stories in height and enjoys one of the city's highest points. This imposing structure could be seen for miles and remains the town's most impressive landmark. It was restored in 2000 to its former glory and continues to be a testament to the stature enjoyed by Waxahachie at the beginning of the last century.

Trinity University moved to Waxahachie in 1902, which further solidified the town's prominent stature. A Jacobethan-styled building was constructed at the northwest edge of the community. A girls' dormitory was built in 1911, and a gymnasium was added in 1926. The location of Trinity University also expanded the residential area around the school. Popular architectural styles are reflected in the homes built between 1905 and 1925 and include prairie-style homes, arts and crafts, brick Tudor homes, and bungalows. Streetcar service connected this area to downtown and other parts of the city.

The social and cultural prominence of Waxahachie at this time was also reflected by the construction of the Chautauqua Auditorium in 1902. Part of the nationwide Chautauqua movement that began in Lake Chautauqua, New York, the assemblies were held in the summer months. The first assembly held in Waxahachie was in 1900. More than 75 tents sheltered the hundreds of people who set up camp in the area around the original pavilion to remain close to the activities, which included religious, educational, and musical events. In 1902, the first Chautauqua assembly was held in the new Chautauqua Auditorium. The event was a huge success, with more than 200 tents set up. The assemblies continued each year until the mid-1920s, when attendance fell dramatically.

During the first decades of the 20th century, the public school system conducted a major building program. Old Marvin College was the first educational facility, but soon schools were built in other sections of the city. The Oak Lawn School provided educational facilities for the town's African American students, and it first opened in 1887. In 1904, a three-story brick building known as Park School was erected in front of Marvin College. The Ferris or Fourth Ward School was built on Gibson Street near the textile mill in 1911. The building is now the home for Waxahachie Independent School District's administration offices. The South Ward School was constructed in 1913 for students living on the south end of town. The classically designed high school was completed in 1918 and is now used for Global High School.

The town also boasted two Presbyterian churches, which built new facilities during the early 20th century. In 1917, Central Presbyterian Church hired Dallas architect C. D. Hill to design their new sanctuary on North College Street. Hill's most visible work was on Swiss Avenue, Munger Place, and South Boulevard in Dallas. In 1916, the First Presbyterian Church constructed their new house of worship on West Main Street. The building is a fine example of Beaux-Arts details, with its modified Doric columns and art glass windows.

The wealthy citizens of Waxahachie also gave back to their community. Nicholas P. Sims, a prominent farmer, donated his estate to build a public library for Waxahachie. The classic Renaissance-style building with Doric columns was one of the more expensive buildings in town, at a cost of $24,980.95. It first opened to the public on April 26, 1905, and was one of the first public libraries in Texas. Waxahachie's first mayor, Capt. W. H. Getzendaner, donated the land for the library, and it instantly became the epicenter for educational and social events in the town. Also at this time, Getzendaner Park was established by a donation of land from the Getzendaner family. The Chautauqua Auditorium is located on land donated by this prominent family.

Waxahachie became connected to Dallas through the interurban line in 1912. The interurban was an electric rail system that was much cheaper and operated more frequently than the railroad passenger trains. By 1914, the interurban line extended 60 miles south to Waco. It successfully

connected Waxahachie to other parts of the state for more than 30 years, but it was closed in 1949 because of the popularity of the automobile.

Dr. W. C. Tenery founded the town's first hospital in 1914. Known as the Waxahachie Sanitarium, it was first located in a two-story home that sat on a plot of land on West Main Street near the Chautauqua Auditorium. The streetcar line had a stop that was just a short walk from the hospital, which made it convenient for the town's residents to seek medical care. In 1921, the home was replaced with a three-story brick building. In 1965, the name of the facility was changed from Waxahachie Sanitarium to the W. C. Tenery Community Hospital.

After World War I, cotton demand and production continued to dominate the local economy. But competition from farmers in south and west Texas began to chip away at the dominance of Ellis County farmers in the cotton markets. The Great Depression of the 1930s drastically reduced the demand for cotton and was the end of that era of prosperity for Waxahachie. Many of the city's gins, compresses, and cottonseed oil mills were closed. The textile mill, the city's most important employer, closed in 1934.

The story of Waxahachie is one of adaptation, determination, and perseverance. The town with the funny name created a wealthy, vibrant community that was a potent economic force in national trade and commerce. The story of Waxahachie can be traced through her commercial and residential buildings and in her cultural and religious institutions. Prominent families gave back to the community to enrich the lives of her residents. Waxahachie stands today, proud of her heritage and hopeful for the future.

One

THE EARLY YEARS

William H. Getzendaner
was a longtime resident and
community leader of early
Waxahachie. He arrived in the
city in the early 1850s and began
a law practice. After serving with
General Parson's brigade during
the Civil War, he returned to
Waxahachie to resume his legal
career and to begin a private
banking venture with his law
partner, Judge J. W. Ferris, in
1868. This venture began in
a small wood frame building
and later became the Citizens
National Bank of Waxahachie.
That same year, he married
Willa Latimer Neel. In 1872, he
became the city's first mayor and
later represented the area in the
Texas State Senate. (Courtesy
of Ellis County Museum.)

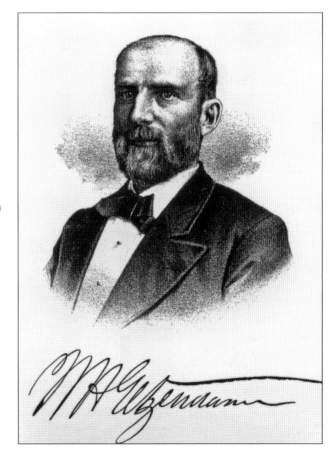

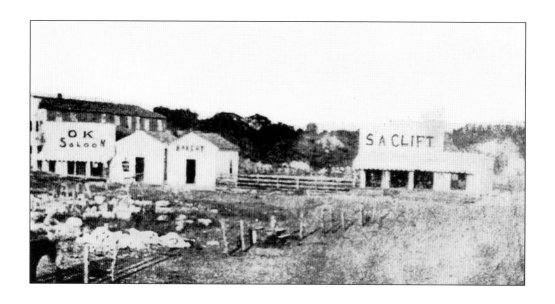

The east side of what is now Waxahachie's downtown square, pictured above c. 1871, included, from left to right, an unmarked building believed to be the Bullard-Spalding building, the OK Saloon, an unidentified building, a bakery, and S. A. Clift, which is believed to have been a merchandise store owned by Stephen A. Clift. Clift, 49 years old at the time, died in the fire of May 1882 that destroyed the Siddons Hotel. The west side of downtown Waxahachie, pictured below c. 1871, consisted of a row of wooden buildings. The sign on the second building from the left states its preference, "Groceries. Cheap for Cash." To its right is the W. T. Briggs Drugstore. Briggs, a physician, was one of the earliest doctors in the county, arriving in Waxahachie in the 1850s. (Both courtesy of Ellis County Museum.)

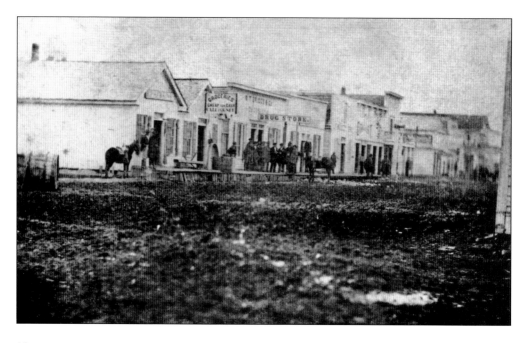

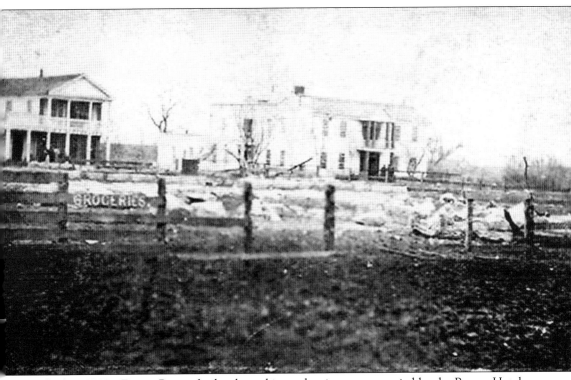

In the late 1840s, Emory Rogers built a log cabin at the site now occupied by the Rogers Hotel at 100 North College Street. In the mid-1850s, he built a two-story wooden structure, pictured above and to the right *c*. 1871, which he called Rogers House. He ran advertisements in the *Dallas Herald* that described his establishment as a "large and commodious hotel." He later sold the hotel to John S. Siddons. Siddons, who was one of Waxahachie's first elected aldermen in 1871, owned the hotel until he sold it in 1881 for $5,500 to the Waxahachie Real Estate and Building Association. In May 1882, a fire destroyed that building. That same year, construction began on a new masonry Rogers House that would later come to be known as Rogers Hotel. This structure stood from 1882 to 1911 when it was destroyed by fire. It was replaced with the present-day Rogers Hotel, constructed in 1912. The total cost was just over $18,000. Also pictured above and to the left *c*. 1871 is Marchbank's Grocery. A. D. Marchbanks opened one of the first stores in the area in around 1850. (Courtesy of Ellis County Museum.)

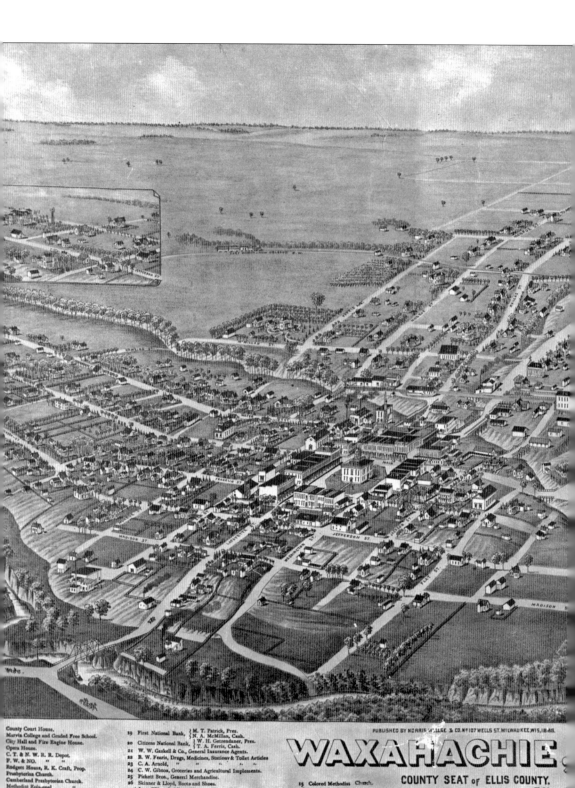

County Court House.
Marvin College and Graded Free School.
City Hall and Fire Engine House.
Opera House.
C. T. & N. W. R. R. Depot.
F. W. & N O.
Rodgers House, R. K. Craft, Prop.
Presbyterian Church.
Cumberland Presbyterian Church.
Methodist Episcopal "
Baptist "
Christian "
Catholic "

19 First National Bank, { M. T. Patrick, Pres. / N. A. McMillen, Cash.
20 Citizens National Bank, { W. H. Getrendaner, Pres. / T. A. Ferris, Cash.
21 W. W. Gaskell & Co., General Insurance Agents.
22 R. W. Fearis, Drugs, Medicines, Stationy & Toilet Articles
23 C. A. Arnold,
24 C. W. Gibson, Groceries and Agricultural Implements.
25 Pickett Bros., General Merchandise.
26 Skinner & Lloyd, Boots and Shoes.
27 { Jesse Wiley, Saddlery, Harness, Whips, Etc. / B. H. Latimer, Staple and Fancy Groceries.
28 A. M. Dechman & Son, Staple and Fancy Groceries.

15 Colored Methodist Church.
16 " Baptist "
17 African M. E. "
18 Colored Free School.

29 W. Schuster,
30 H. Cerf, Groc
31 P. F. Deveapo

PUBLISHED BY NORRIS WELLGE & CO. N° 107 WELLS ST. MILWAUKEE, WIS. 1886.

WAXAHACHIE,
COUNTY SEAT OF ELLIS COUNTY.
1886.

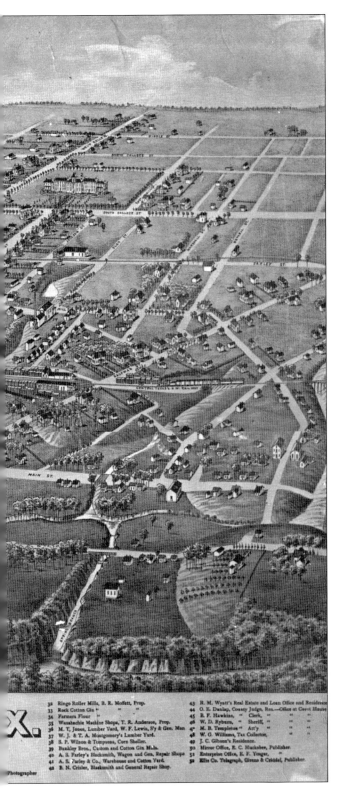

By 1886, the rail had arrived, as depicted in the upper left-hand portion of the map. The scattering of residential homes from a decade earlier have been replaced by a community landscape that is rapidly expanding. In contrast to a similar map of a decade before, this legend details a number of structures not found earlier. Businesses include First National Bank at Lafayette and Franklin Streets; Citizens National Bank; Pickett Brothers General Merchandise at Main and Lafayette Streets; an opera house; the CT&NW Railroad Depot; the FW&NO Railroad Depot; Skinner and Lloyd Boots and Shoes; Jesse Wiley Saddlery, Harness, and Whips; B. H. Lattner Staples and Fancy Groceries; the Enterprise Office, manned by E. F. Yeager and located in the first two-story building on Washington Street across from the courthouse; C. W. Gibsons Groceries and Agricultural Implements; the Rodgers House at Main and Lafayette Streets; the Rock Cotton Gin, owned by B. R. Moffett in the lower left-hand corner off Madison Street; and S. P. Wilson and Tompson Corn Sheller at the left-hand corner on the banks of the Waxahachie Creek. Churches were within blocks of the courthouse square, and Marvin College was at the upper edge along South College Street. (Courtesy of Ellis County Museum.)

15

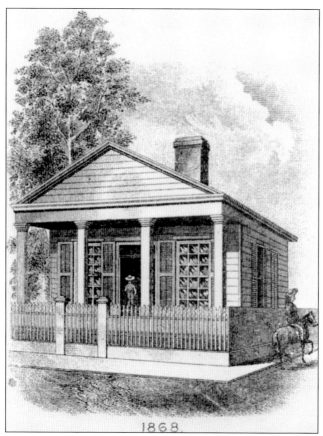

1868

In 1868, J. W. Ferris and William H. Getzendaner opened a law office in the small wood frame building depicted in the sketch at left. It was located on East Main Street in the vicinity of Jackson Street. Not long after, they added a banking endeavor to their efforts, creating the Citizens National Bank of Waxahachie. At the beginning of the 20th century, horses and buggies still filled the streets, as pictured below at a First Monday Jockey Yard event. The Waxahachie Hardware Company is the second building from the left, located on South Washington Street, which would later become 214–216 South College Street. (Both courtesy of Ellis County Museum.)

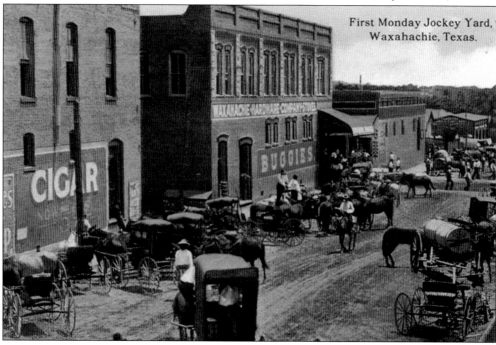

Families were also moving to the city and building homes and businesses. Pictured above is a scene from along the 1000 block of Main Street. Many of these homes still stand. C. E. Youngblood Cash Grocery, located on the first floor of the Hancock Building, is pictured below c. 1900. Occupying the right side of the ground floor space of the building, then 203 Washington Street, the address would now be 207 South College Street. (Both courtesy of Ellis County Museum.)

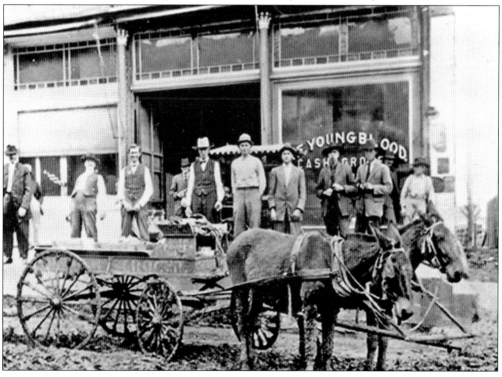

The S. Y. Matthews home was located at 423 West Main Street, the modern address now being 1121 West Main Street. Matthews came to Waxahachie in 1890 and opened Matthews Brothers Gents Furnishings with his brother. The Matthews children and others are pictured, with the Osce Goodwin home in the background, including Frances Matthews, Paxton Matthews, Henry Philpott, Ben Smith, Ruth Smith, and Tom Smith. (Courtesy of Ellis County Museum.)

Annie Patrick Kemble (left) and her sister Maude Patrick Hipp are pictured in the living room of their home, the Patrick home, c. 1901. Annie was married in the home in 1903, only a few years after the house was built. (Courtesy of Ann Allen.)

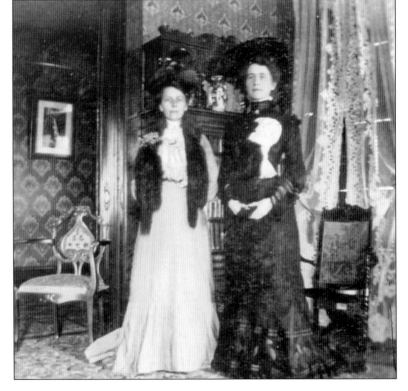

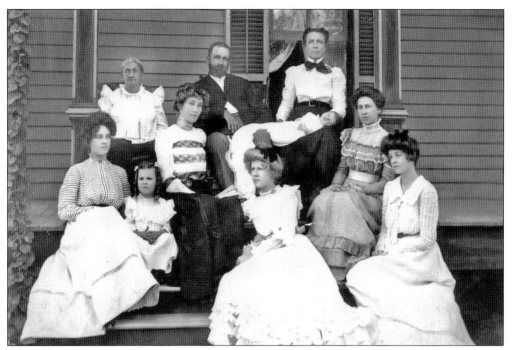

Families were and continue to be an integral part of Waxahachie. Members of the family of C. J. Griggs, a local contractor and builder, are pictured above on the porch of their home at 210 Marvin Street c. 1901. (Courtesy of Ellis County Museum.)

Laura Parks Spalding can be seen in front of the home that is named for her. Once located at the corner of West Jefferson and South Hawkins Streets, it was moved sometime prior to 1909 to its current location at 207 South Hawkins Street. Pictured, from left to right c. 1895, are Kate Spalding, unidentified, Laura Parks Spalding (on the porch), Manuel (also known as Bob), and the pony, Dan. (Courtesy of Peggy Spalding.)

The Jolesch and Chaska Dry Goods Store opened for business in Waxahachie in 1875. The store, pictured above c. 1890, was located at 200–202 South Rogers Street on the corner of Rogers and Franklin Streets. Also on South Rogers Street was Cheeves Brothers Dry Goods Store, pictured below c. 1900. Their establishment was located at 300–302 South Rogers Street on the corner of Rogers and Jefferson Streets. In 1907, they advertised that they carried a "complete and up-to-date stock of valises, millinery, shoes, hats & more." F. C. Rogers managed the store sometime around the 1920s. The second floor of the building housed several offices and businesses, as evidenced by their window signs, including at the far left, "A. Bishop Real Estate Loans," and on the corner of the building, "Hudson Photography." (Both courtesy of Ellis County Museum.)

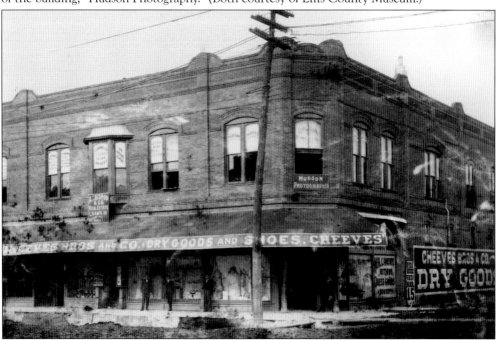

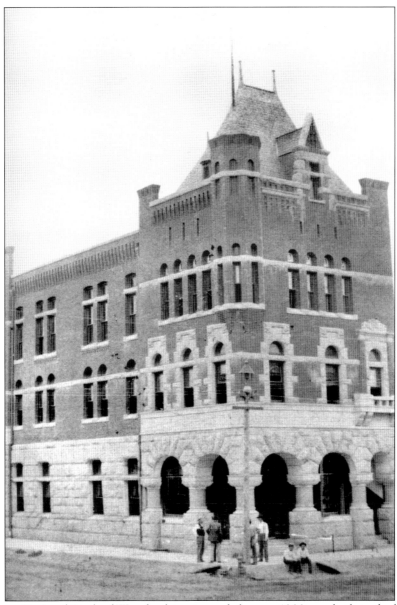

The Citizens National Bank of Waxahachie, pictured above *c.* 1900, was built in the late 1880s. Located at the northwest corner of Main and Rogers Streets, this was the bank's third location, where it remained until 1927. Citizens National Bank was founded in 1868 by Waxahachie pioneers Capt. W. H. Getzendaner and J. W. Ferris. These two attorneys began the banking business as a sideline, with $40,000 in capital. Their first deposit, $230.75, came from Robert A. Davis of Waxahachie. Their first bank building was a small frame structure on East Main Street. Only a block from the square, it also served as their law office. A sign with the word *Bank* nailed to the outside of the building was all that identified what was then a fledgling business. In 1873, the bank moved to a larger structure on the northeast corner of Main and Rogers Streets. In 1886, because of continued growth, it moved to the building pictured above. From these humble beginnings grew a Citizens National Bank that serves Waxahachie still today. (Courtesy of Ellis County Museum.)

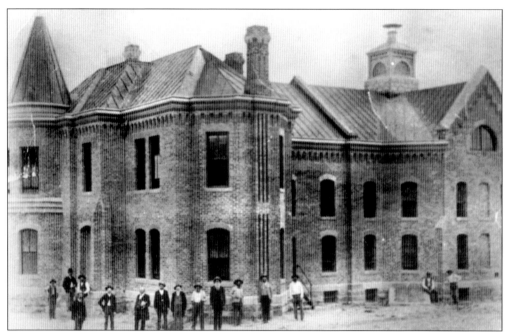

Ellis County's first jail was built in 1854. A 16-by-16-foot square building on the outside, it was made of wood with a single cell on both the first and second floors. In 1875, a new jail was built of stone and measured 33 by 22 feet. Sheriff John T. King served the county at that time. In 1887, when W. D. Ryburn was county sheriff, $35,000 was spent to build a landmark jail in the 200 block of North Rogers Street. The new jail, pictured above c. 1888, contained a revolving cage in its center that opened to the various cells that surrounded it. Pictured below, mail carriers in their delivery buggies head down Jefferson Street on their way to deliver their routes, many of them rural routes. The post office building is to the right, and Graham Earl Elliott is located in the second buggy from the left. (Both courtesy of Ellis County Museum.)

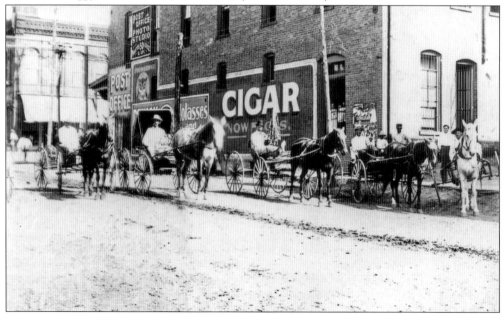

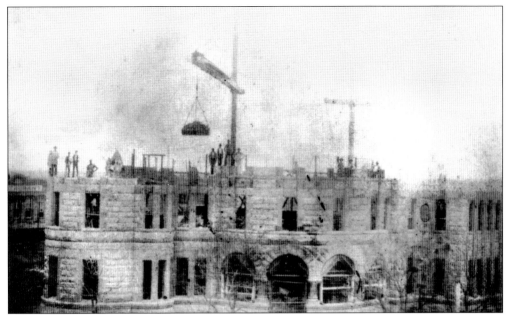

Construction on the fourth Ellis County Courthouse, which still stands today in Waxahachie's town square, began in 1895 and was completed in 1897. Construction underway on the east side of the structure is pictured in the winter of 1896. Seen around and on the structure are some of the 50 to 70 men employed during those years at an average monthly payroll of $5,000. (Courtesy of Ellis County Museum.)

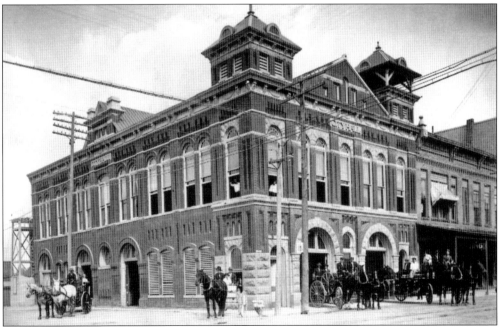

Waxahachie's city hall was built in 1892. Located at the northeast corner of Main and Elm Streets, the land was purchased from the Cumberland Presbyterian Church. Because the city hall also housed the fire department, a bell tower on the top of the building served to call both police officers and volunteer firefighters when they were needed. (Courtesy of Ellis County Museum.)

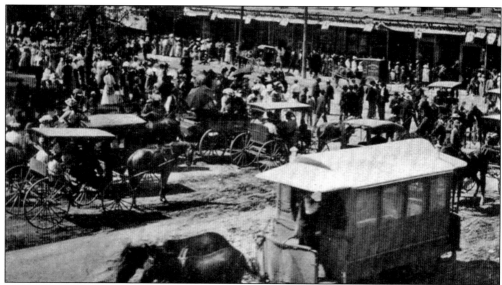

A Waxahachie mule car can be seen in the forefront of a busy Waxahachie town square, *c.* 1903, along Main Street between Rogers and College Streets. The Waxahachie Street Railway Company began operations in 1889. Early directors were O. E. Dunlap, E. A. Dubose, R. G. Phillips, and T. A. Ferris. Mass transportation had arrived in Waxahachie. By 1902, the company operated three open passenger cars and two closed passenger cars. (Courtesy of Ellis County Museum.)

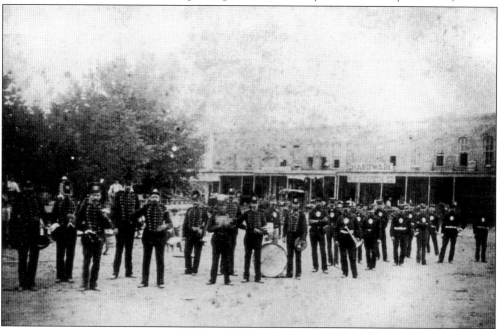

Standing in the downtown square *c.* 1885 are members of the Salamander Fire Company No. 1 band. The fire company was organized in July 1883, a year after fire destroyed a large part of the downtown area. The block of businesses seen in the background to the right, including W. N. Griffeth Company Hardware, are at the south side of the square. The fencing in the center background surrounded the Ellis County Courthouse of that time. (Courtesy of Ellis County Museum.)

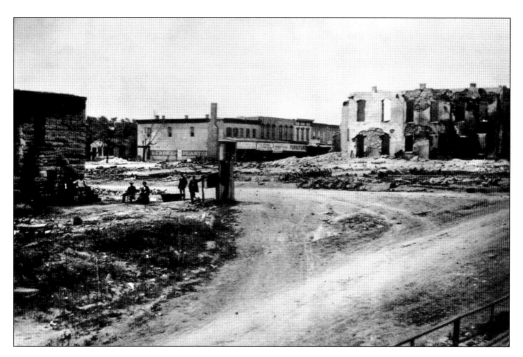

In May 1882, fire destroyed much of the area north of the square and the area between Rogers Street and College Street (at that time known as Washington Street) all the way to the Rogers Branch. The total loss from the fire was estimated to be in the range of $100,000. The aftermath of the fire and the destruction it caused, pictured above, were devastating. Almost a year later, in early May 1883, the city purchased a Silsby Steam Fire Engine, 1,000 feet of hose, and two hose carts for almost $5,000. In October of that year, plans were initiated to build a new fire engine house, pictured below *c.* 1888, at the northwest corner of Rogers and Water Streets, which was located in the center of the area destroyed by the fire the year before. (Both courtesy of Ellis County Museum.)

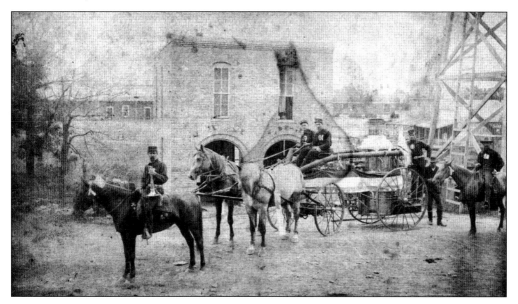

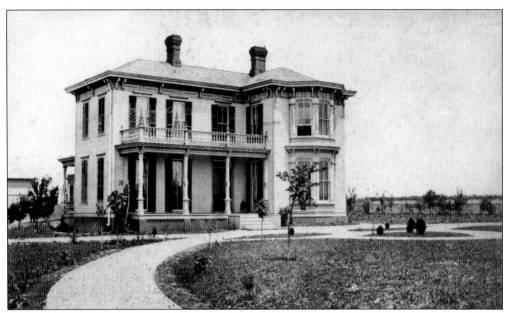

Pictured above is one of the early homes of Waxahachie around the early 1880s. The T. A. Ferris home was located on Ferris Avenue and McMillan Street. Pictured below is the home of Osce Goodwin, c. 1898, which was located at 1122 West Main Street. The home was built by Goodwin c. 1890 and was one of the first homes constructed in the West End. The home has had other owners, including the Trabue family and the Moore family of Will Moore Hardware Company. Goodwin was a lawyer and around 1885 had a law practice with W. H. Harding. He also had several business interests, including the Waxahachie Street Railway Company of which he served as treasurer in the late 1890s. (Both courtesy of Ellis County Museum.)

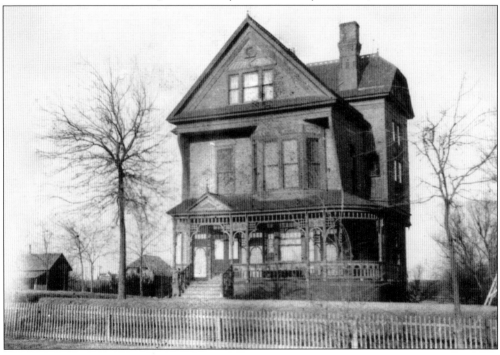

The Fines P. Powell home was built in 1892. Located at the northwest corner of Marvin and Bryson Streets, it is pictured to the right c. 1898. Powell, a Waxahachie lawyer, and his wife, Myrtle, a former school teacher and the first president of the Waxahachie Shakespeare Club, chose a George F. Barber catalogue design for their home. They contracted builder W. H. Smith to construct the home for $3,000. Powell obtained a savings association loan for the construction, which he paid off early only four years later. H. W. Leeper built the home at 1202 West Main Street in 1895. Pictured below c. 1898, the home was later owned by the family of Waxahachie dentist Dr. W. B. Ferguson. (Both courtesy of Ellis County Museum.)

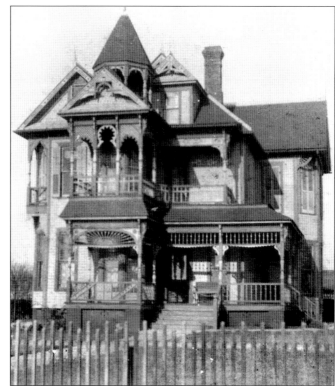

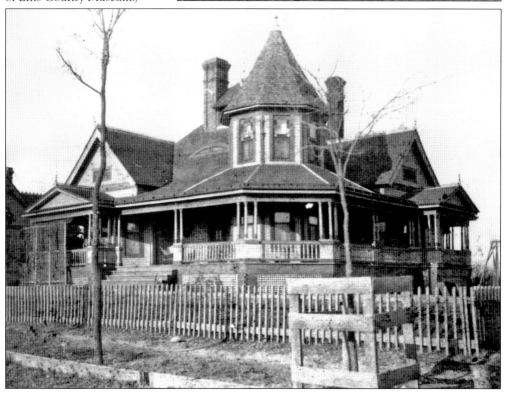

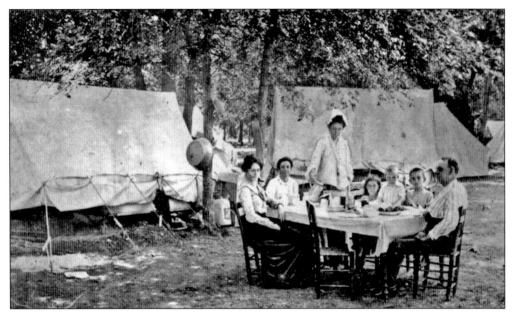

In 1889, several young women, including Willia Getzendaner, Flora McMillan, Scotta McMillan, Mary Siddons, Zephie Trippet, and Ruth Wyatt, formed the Sappho Chautauqua Literary and Scientific Circle. Eleven years later, the first Chautauqua was held in Waxahachie, sponsored by the Presbyterian Church. Chautauqua assemblies were held for one week in July. By 1900, almost 100 tents provided shelter for the hundreds who came to attend the Bible studies and educational lectures held at the pavilion in the West End Park. There was also entertainment for the campers, including jugglers, poets, humorists, and choral groups. Pictured above are campers c. 1902 sitting down for dinner, and below are Chautauqua campers posed outside their tents. (Both courtesy of Ellis County Museum.)

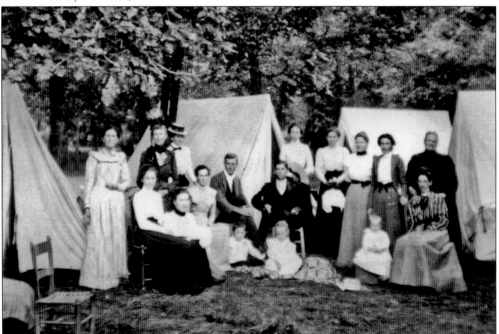

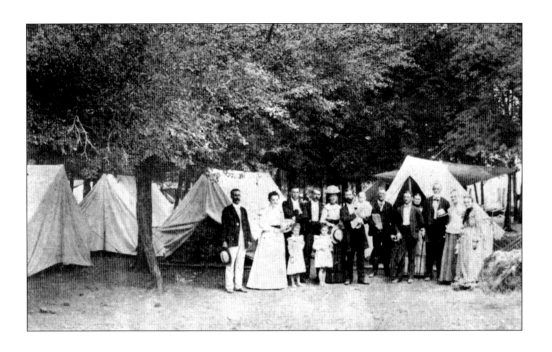

In 1902, the Chautauqua Park Association was formed, and in 1914, the park area surrounding the auditorium, over 50 acres, was deeded to the city by Ralph and Helen Getzendaner. Pictured above is the area surrounding President McConnell's headquarters at the Chautauqua program of 1902. Pictured below is the auditorium interior c. 1903, where over the years, many gathered to hear Will Rogers, William Jennings Bryan, and others. Attendance to the assembly decreased in the 1920s. (Both courtesy of Ellis County Museum.)

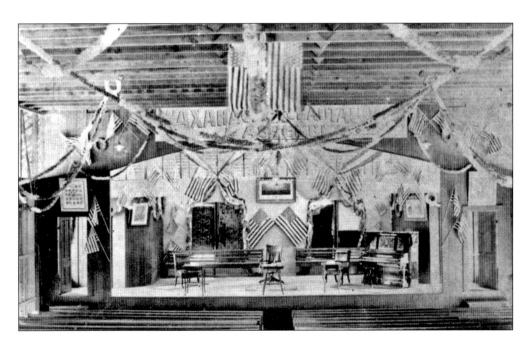

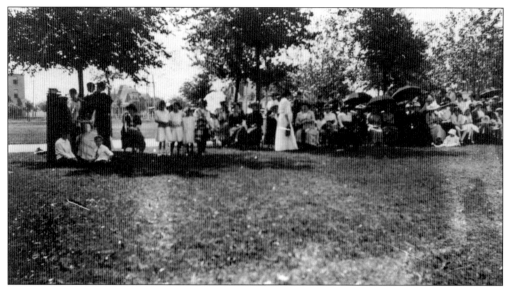

On the grounds of Park School, once the location of Marvin College, there appears to be a gathering of all ages for a piano recital c. 1900. An upright piano can be seen to the far left, around which many of those attending are gathered. To the right, the use of umbrellas suggests a sunny day. (Courtesy of Ennis Public Library.)

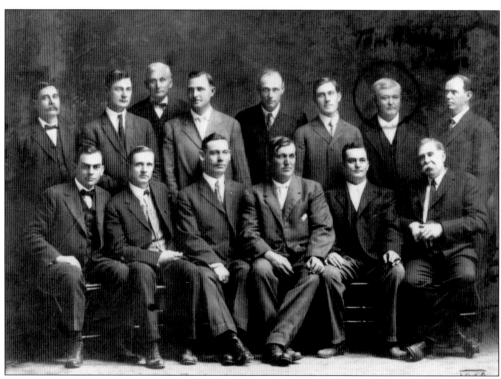

Ellis County officials are pictured c. 1912. Included in those officials are the county commissioners, court clerk, tax collector, sheriff, tax assessor, and district judge. Judge Thomas Percival Whipple is pictured second from the right in the second row. (Courtesy of Ellis County Museum.)

Two

ALONG THE STREETS
OF WAXAHACHIE

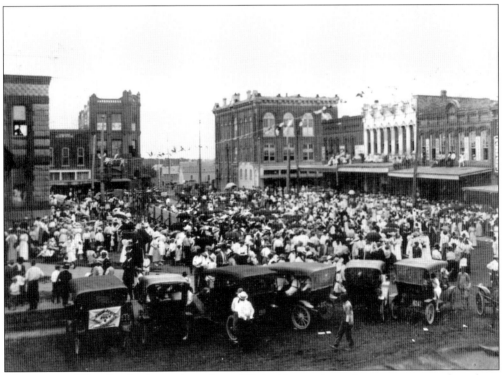

The streets of Waxahachie have always been filled with people, and no area more so than those streets surrounding the Ellis County Courthouse. The crowds above can be seen along Franklin Street c. 1915. It is possible that the crowds were gathered at the square and on the surrounding rooftops to watch for progress in an election. The back sides of propped up boards, which can be seen in front of the courthouse facing the crowds, may be the means of keeping up-to-date vote counts available. The view is one looking southeast down Franklin Street. (Courtesy of Ellis County Museum.)

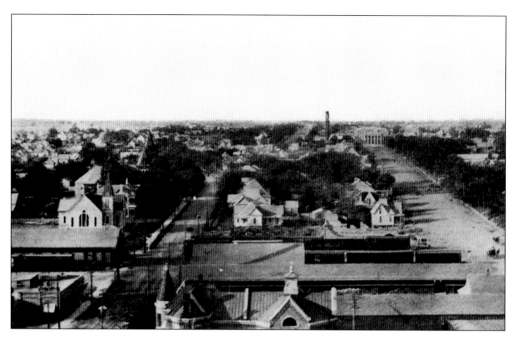

Waxahachie continued to grow in population and enterprise in the first decade of the 20th century. Pictured *c.* 1910 are north-looking views of the city from the upper levels of the Ellis County Courthouse, located in the center of the town square. Pictured above running along the left side of the photograph, from left to right, are the First Presbyterian Church and the First Baptist Church. At the end of the street, running along the right side of the photograph at the upper edge, is Park School. Pictured below in the lower center of the photograph, with its distinctive turret, is Citizens National Bank. To the left at the end of that block are the city hall and fire department at Main and Elm Streets. (Both courtesy of Ellis County Museum.)

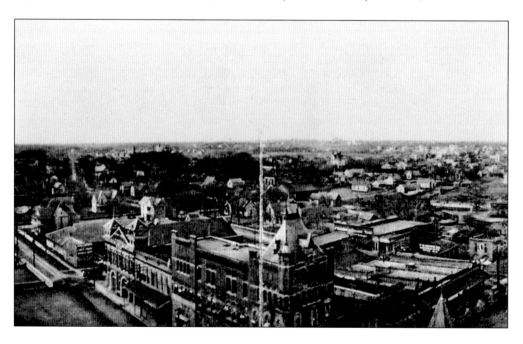

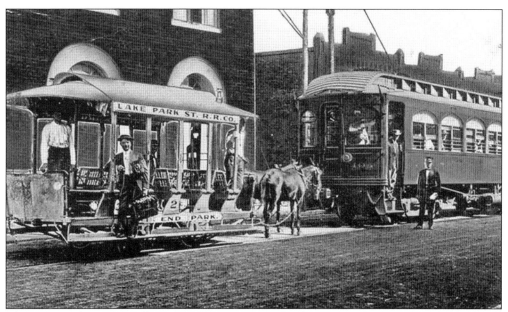

The Lake Park Street Railway Company was Waxahachie's second mule car line that began operations c. 1892. Directors of the new company included W. E. Coleman, F. M. Dannelly, J. F. Dunlap, J. C. Fears, E. H. Griffin, W. F. Lewis, L. H. Peters, J. C. Smith, and R. Vickery. Financially bankrupt, the company was sold in 1895 to Fount Ray, who represented R. Vickery. In 1902, the company operated three closed passenger cars, one open passenger car, and one combination open-closed car. The Texas Electric Railway Company began operations in 1913, the same year the mule car lines ceased operations. Pictured above c. 1913 on North College Street behind Curlin's Pharmacy, a Lake Park mule car and interurban car meet. Just a few years later, the interurban can again be seen on College Street, as pictured below. The courthouse can be seen to the left. (Both courtesy of Ellis County Museum.)

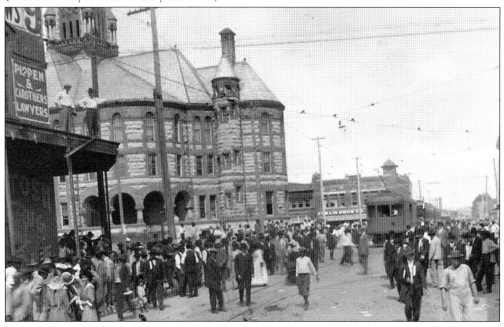

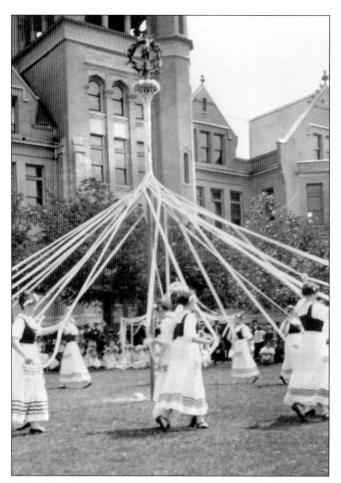

The campus of Trinity University, bordered by East University and Sycamore Streets, was often the scene of community gatherings. Pictured are scenes from what appears to be a May Day celebration *c.* 1920. (Both courtesy of Ennis Public Library.)

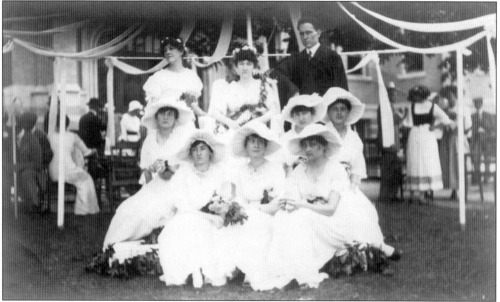

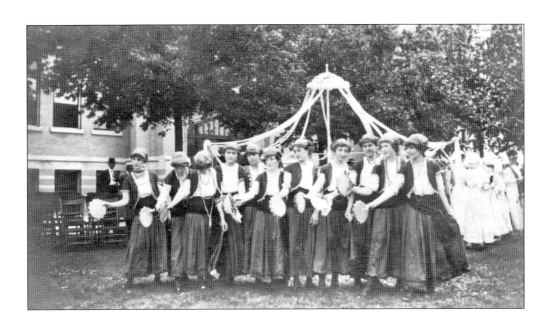

Young women dressed in costume and sporting tambourines are pictured above. They are part of the celebration being held on the grounds of Trinity University, pictured below. In 1942, the university closed its door in Waxahachie and relocated to San Antonio. (Both courtesy of Ennis Public Library.)

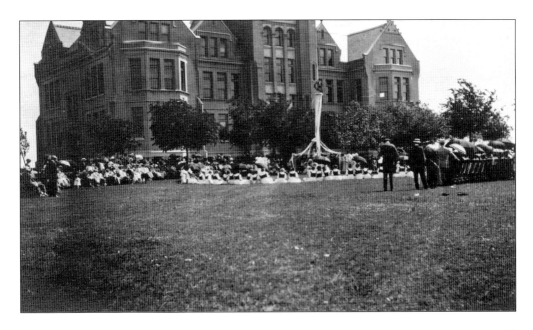

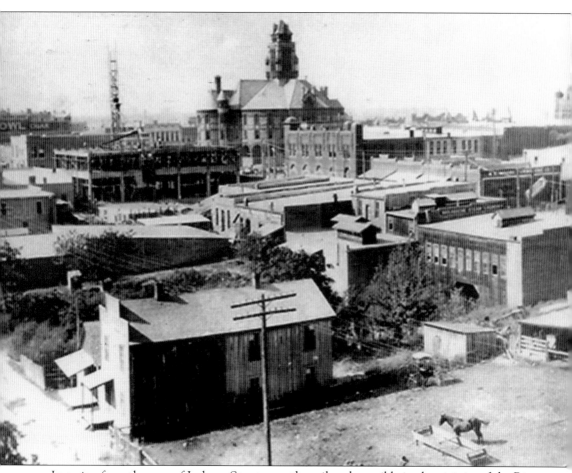

In a view from the area of Jackson Street near the railroad, possibly in the vicinity of the Ringo Roller Mills that was owned by B. R. Moffett, the construction of Rogers Hotel on North Washington Street c. 1911 is portrayed. Just beyond the construction, the courthouse and surrounding downtown area are visible. A portion of North Jackson Street is visible along the lower left side of the photograph. Businesses located on that block at the time included F. E. Barnes, vet surgeon; August Kerr, cleaner and presser; and B. B. Williams, barber. The back sides of buildings along North Washington Street (now College Street) are seen to the right of the photograph. Several businesses lined both sides of the block to the north of the Rogers Hotel, including Waxahachie Steam Laundry; R. E. Moore Furniture Company; Leach and Faulkner, tailors; Frank Bishop, barber; E. L. Feray Meats; Middleton Printing Company; Wells Fargo and Company Express; Southern Traction Company; Thomson Jewelry Company; and W. T. Evans, confectioner. (Courtesy of Ellis County Museum.)

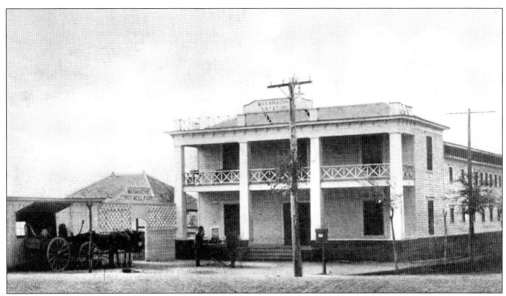

In 1907, while drilling for water for municipal use on East Madison Street, mineral water was discovered. In April 1908, Pete Ellis, J. H. Wakeland, C. E. Schuster, S. P. Spalding, and N. J. Thomas formed the Waxahachie Hot Wells Natatorium Company. Their hope was that the natatorium would make Waxahachie a resort town, drawing visitors interested in the health benefits of the mineral water drawn from the almost 1,000-foot-deep artesian well. The natatorium was built on Clift Street between Jefferson and Madison Streets on property that was once a wagon yard. Inside the natatorium was a pool that measured 20 feet by 70 feet, and around it were two levels of bathrooms. The facility, pictured above, closed around 1910. The Waxahachie Country Club, pictured below, is still located at the far end of West Main Street after it turns into Business Highway 287, going towards Midlothian. It opened in 1924 and featured a golf course and lake activities. (Both courtesy of Ellis County Museum.)

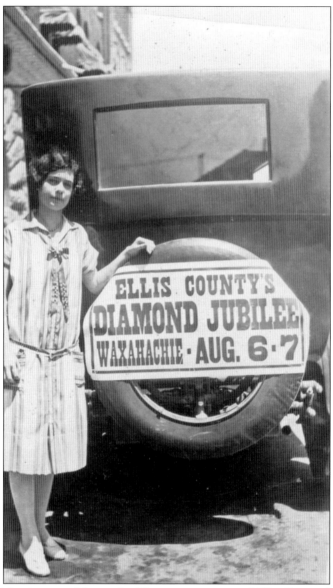

The two-day celebration to celebrate the 75-year anniversary of Ellis County began Thursday, August 6, 1925. Held in Waxahachie, the Diamond Jubilee captured the attention of residents countywide. Over 10,000 attended the first day's events, which included a parade that honored the county's former soldiers and early pioneers, all of whom were guests of the Waxahachie Chamber of Commerce, which was a sponsor of the jubilee. That evening at the Getzendaner Memorial Park, over 1,000 actors participated in a portrayal of the county's history, which was written and arranged by Maude Farrar of Waxahachie. Among those who participated were John Arden, Dorothy Burleson, Rev. Clay Collier, John Cunningham, Katie Daffan, Lynette Douglass, Frances Eddlemon, E. P. Hawkins, Augusta Mahaney, Burton Prince, and Rila Boren Ray. Nine duchesses from around the county competed for the position of jubilee queen, including Marguerite Arden of Ennis, Cathelene Batchelor of Ferris, Fredna Cross of Italy, Mattie Brooks of Maypearl, Catherine Morrell of Milford, Lois McElroy of Midlothian, Mary Jackson of Palmer, and Frances Brady (winner) and Josephine Wilson, both of Waxahachie. (Courtesy of Ann Allen.)

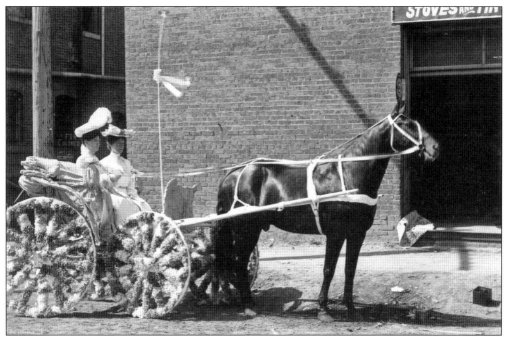

The residents of Waxahachie gathered often for social events and other community celebrations. Pictured above in a carriage decorated and ready for one of Waxahachie's many parades is Elizabeth Prince (left.) Her husband, Burton, owned the Harness Store at 303 South Rogers Street. Also ready for a parade are Clara Boyd, Alpha Penn, and Margaret Kemble, pictured below *c.* 1901. They are seen at the corner of Rogers and Main Streets at what may have been an early Easter parade. (Above, courtesy of Ellis County Museum; below, courtesy of Peggy Spalding.)

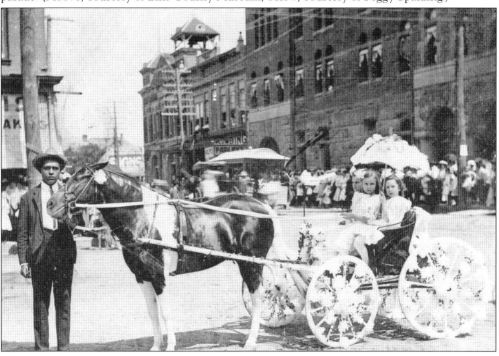

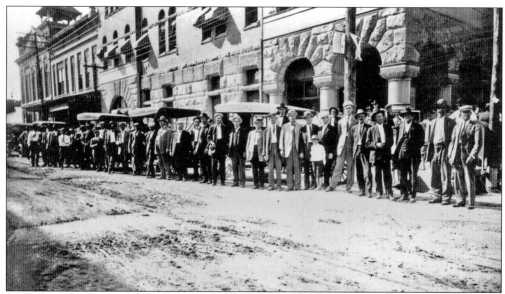

In May 1911, men from the Falls County delegation, pictured above, visited the city to observe the good roads of Waxahachie. Behind them is the Citizens National Bank. Boy Scouts returning from a camping trip at Joe Taylor's farm in Palo Pinto in August 1921 are seen pictured below at the intersection of South Rogers and Madison Streets. From left to right in front of the car are Sidney Farley, Loys Sessions (scoutmaster), Everett Tucker, and Joe, their cook. Among those gathered on the truck are Frank McQuaters, Walter Watson, Harry Holland, Ray Lowry, Weldon Tucker, Herbert Peters, James Harbin, Goodwin Sweatt, Jack Rushing, Kerr Jones, Eddie Harrell, Robert Stewart, Maurice Stiles, W. B. Forrest, Tim Ferguson, Cecil Manning, James McRoberts, R. F. Chapman (assistant scoutmaster), Truett Creagor, Cecil McLain, Chauncy Acrey, J. W. Thompson, Atreus Deavers, Aldridge Lomax, Henry Mays, and Hastings Ackley. (Both courtesy of Ellis County Museum.)

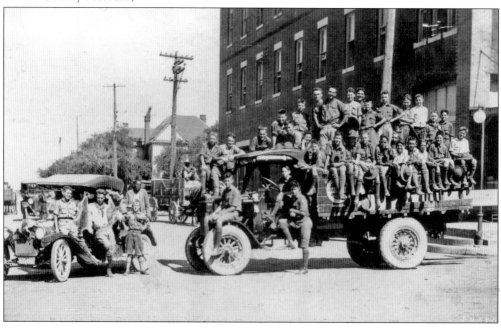

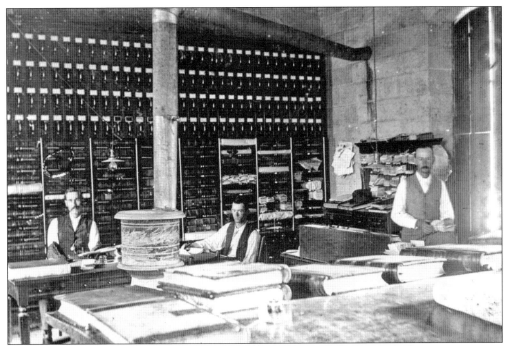

In 1886, the county built a structure beside the courthouse to provide it with the space necessary to store the growing number of county records. The new county clerk's office, pictured above, was in use through 1895, when it was torn down to make way for the construction of the fourth courthouse at the site. (Courtesy of Ellis County Museum.)

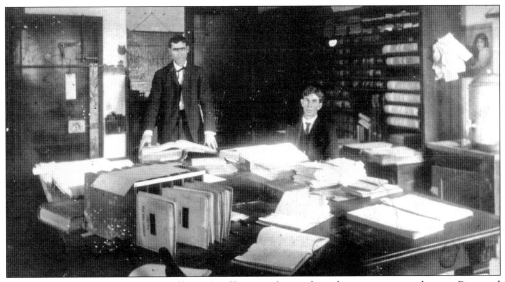

The Ellis County tax assessor collector's office was located in the county courthouse. Pictured in the tax assessor collector's office c. 1890 are Jess Kennedy (left) and S. L. Killebrew. (Courtesy of Ellis County Museum.)

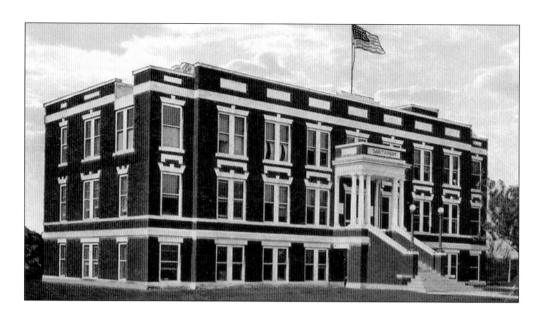

The Waxahachie Sanitarium, pictured above, was built in 1921. It replaced an earlier hospital, located on West Main Street near Chautauqua Park, which had opened in 1914. This first hospital had an operating room, an isolation room, three wards for patients on the second floor, a laboratory, and a private apartment for the resident nurse, Mrs. Barnes. The new hospital was the result of a meeting a year earlier that included John B. George, W. W. Mincey, Dr. L. D. Parnell, Dr. W. C. Tenery, and S. P. Spalding to address the community's need for a place to treat patients needing long-term care. It was named the W. C. Tenery Community Hospital in honor of the Waxahachie doctor instrumental in its construction. Pictured below are some of the nurses who served their community in the Waxahachie Sanitarium. (Both courtesy of Ellis County Museum.)

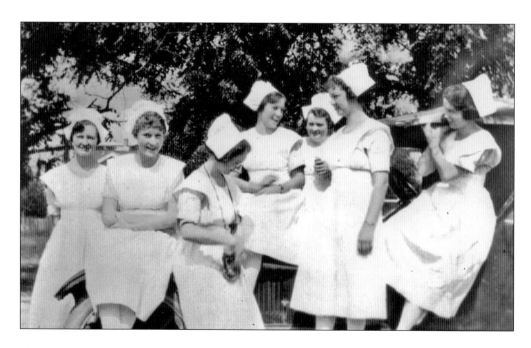

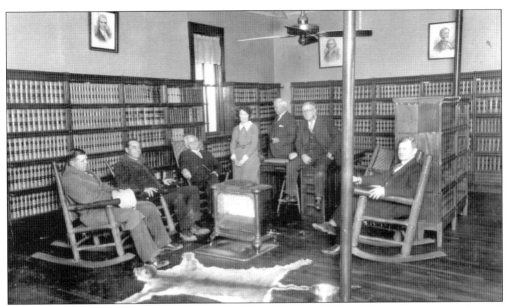

As early as the late 1800s, the Hancock Building, located at 205 South College Street, housed the law offices of W. L. Harding, Fountain P. Ray, and M. B. Templeton on the second floor of the building. The first floor was the location of retail shops that in 1898 were occupied by Gents Furnishings, owned by S. Y. Matthews, and C. E. Youngblood's Cash Grocery, located on the right side of the first floor. In 1907, the building was purchased by William P. Hancock, C. O. Atkins, and W. G. McClain. Hancock later gained full ownership. Pictured above with him in his law office in February 1930, from left to right, are unidentified, attorney Louis Johnson, justice of the peace Bill Cox, Miss Ross, attorney Tom P. Whipple, Dr. W. B. Ferguson, and Will Hancock. Pictured below in their offices are William Hancock and his secretary, Miss Ross. (Both courtesy of Ellis County Museum.)

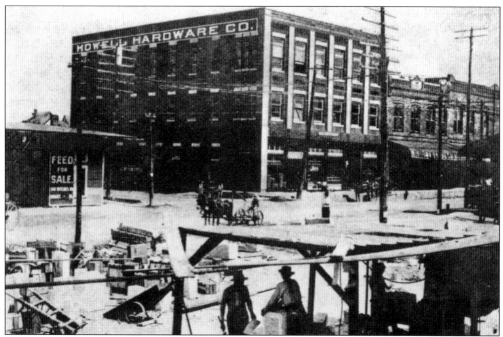

Waxahachie's first post office, established in 1850, was located on Solon Road. The first postmaster was Joseph Whitenburg. The next post office location, also chosen because it was on the stage line, was in a pasture where the MK&T rail crossed Ovilla Road. In the late 1880s, it was moved to the Rogers Hotel building, where it remained until it was relocated again in 1899. Needing more space, an area in the Edens Building at South Rogers and Jefferson Streets was leased. The post office remained at this location until construction began in 1911, as pictured, on the fifth location at South Rogers and Madison Streets. (Both courtesy of Ellis County Museum.)

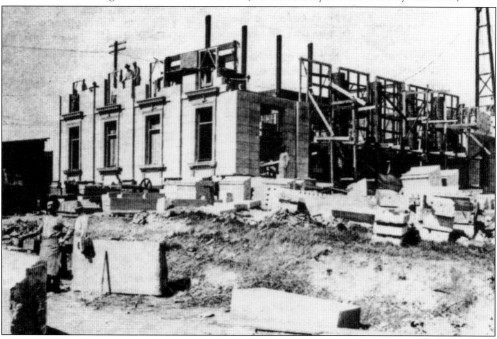

While residents of Waxahachie were served by a U.S. post office since 1850, it was not until 1901 that free city delivery of the mail began. At that time, located in their fourth facility and pictured above c. 1905, they worked out of a leased 30-by-78-foot space in the Edens Building. The postmaster at that time was John Beaty. It would be almost a decade later when they moved into the city's first federal U.S. post office building, pictured below, which was completed in 1912. (Both courtesy of Ellis County Museum.)

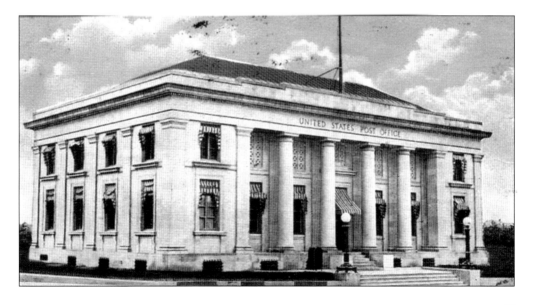

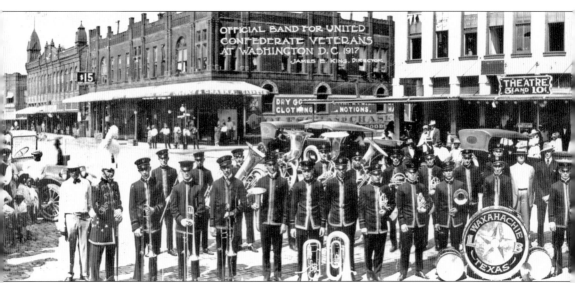

The Lone Star Band formed in 1910 when John Sawyer approached Trinity University student J. Norris Crawford wanting to learn how to play his coronet. Soon Crawford was giving music lessons to Sawyer and over a dozen other young boys. Band members paid membership dues, which entitled them to private lessons. After Crawford graduated from the university, Patrick Sims took over and was later joined by band director James E. King of Mexia. The band was in much demand

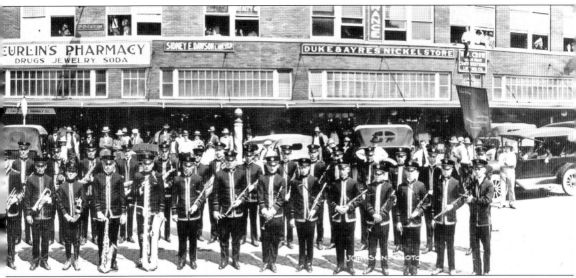

and regularly performed at the Chautauqua Auditorium and the Rogers Hotel garden roof. In 1917, they were named the official band of the United Confederate Veterans and led the group's reunion parade in Washington, D.C. They are pictured above in a photograph commemorating that role, standing along Rogers Street looking towards the west side of the courthouse square. (Courtesy of Ellis County Museum.)

Through the decades, the streets of Waxahachie have seen snowstorms and the beginning of a hometown enterprise. Making their way through the cold and snow in the front yard of the S. Y. Matthews home on Main Street *c.* 1903, from left to right, are Henry Philpott, Frances Matthews, and Ruth Smith. Pictured below is the beginning of Burleson Honey, which began in the backyard of the Burleson home at 1206 West Main Street in Waxahachie. Pictured next to the Burleson house at the left, from left to right, are Thelma Burleson, T. W. Burleson, and T. E. Burleson Sr. (Both courtesy of Ellis County Museum.)

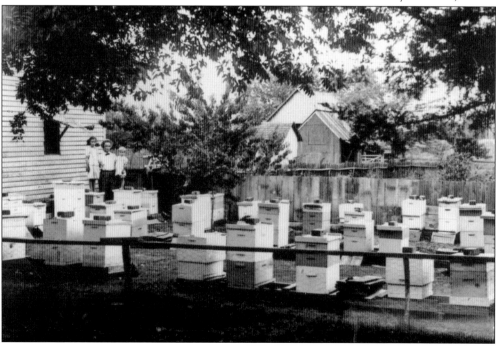

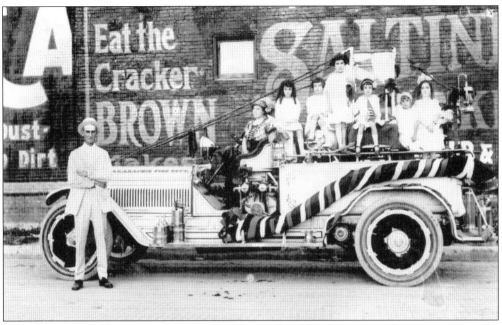

Parades were a family event in Waxahachie. Pictured is a family awaiting their entrance to the parade in the fire truck decorated for the event. (Courtesy of Ellis County Museum.)

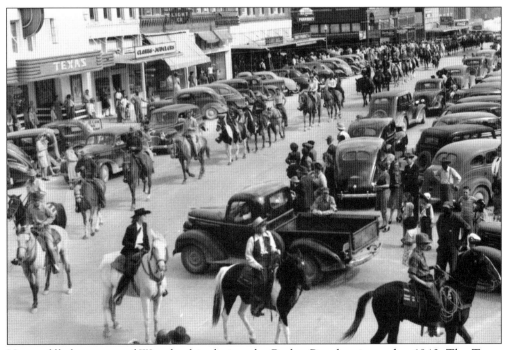

Horses fill the streets of Waxahachie during the Rodeo Parade, pictured c. 1940. The Texas Theater can be seen in the background, providing a view of Main Street looking east. (Courtesy of Ellis County Museum.)

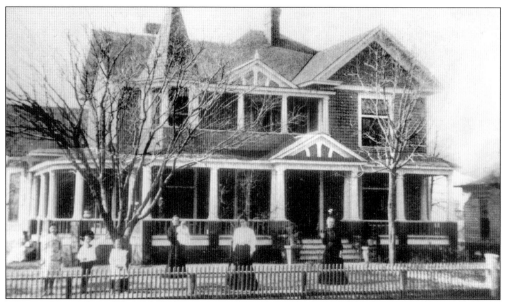

Thomas McDade and his family lived at 208 Oldham Avenue, pictured above *c.* 1895. McDade was a druggist and owned his own drugstore in the heart of Waxahachie on Franklin Street on the south side of the square. The family of Jack Beall also lived in a home on Oldham Avenue, pictured below *c.* 1898. Beall served in the Texas State House of Representatives from 1892 to 1894; the Texas State Senate, representing the 10th district from 1895 to 1898; and the U.S. House of Representatives, representing Texas's 5th district from 1903 to 1915. Early in his career, in the early 1880s, Beall taught school. He later graduated from law school and began a law practice in Waxahachie *c.* 1890. (Both courtesy of Ellis County Museum.)

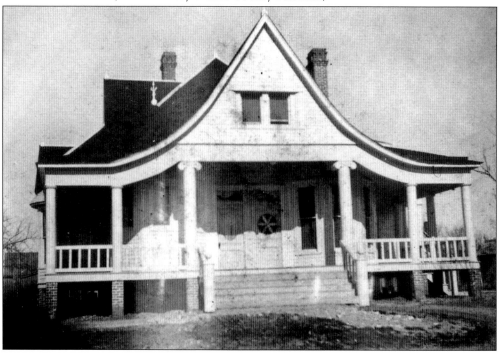

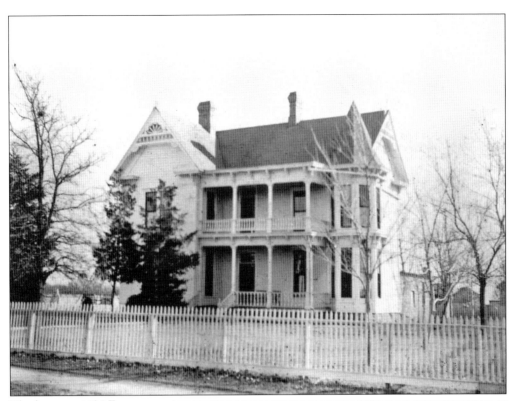

The home at 1104 East Marvin Avenue was owned by Richard Vickery, who immigrated to Ellis County by way of Michigan from Devonshire, England. Vickery owned property in both Ellis and Tarrant Counties, including the Lake Park Street Railway Company of Waxahachie, and held the position as one of the directors of the Waxahachie National Bank board in the early years. In early records, he was a confectioner and later a real estate agent. Pictured at right c. 1910 is the home located at what was then 201 Vickery Street. It was once the home of Rachel Whitfield Ridgeway Hancock. (Both courtesy of Ellis County Museum.)

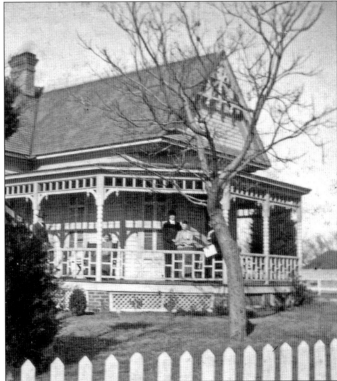

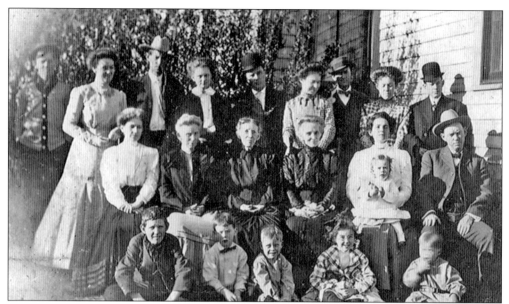

Families and children gathered often along the streets of Waxahachie. Members of the Spalding family are pictured above, at Christmas of 1909, in the back of the family home at 207 South Hawkins Street. Pictured from left to right are (first row) Robert, Albert, Joseph and Dorothy Spalding, and unidentified; (second row) Willie Spalding, Laura Parks Spalding, Martha Parks Rowen, Sarah Parks Morris, Mary Fancher Spalding, Edward Spalding (on lap), and Clint Spalding; (third row) unidentified, Kate Spalding, Carr Morris, Mary Bullard, unidentified, Annie Morris, Frank Spalding, Mossie Emerson, and unidentified. Pictured below is one of the many generations that have lived in the home that Walter Patrick built. From left to right c. 1915 are Emily Kemble Graham, Josephine Wilson Ruskin, Margaret Spencer McWhirter, and Rebecca Kemble Sawyer. The two Kemble girls were Patrick's granddaughters. (Above, courtesy of Peggy Spalding; below, courtesy of Ann Allen.)

Three

A Bustling Hub
of Commerce
and Enterprise

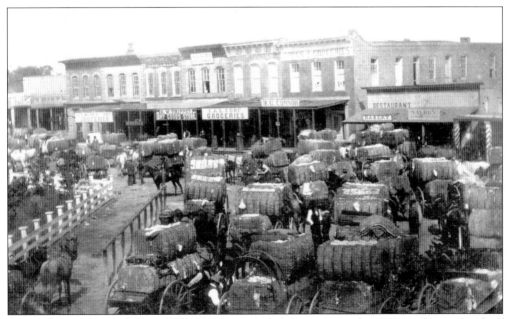

Some of the early merchants of Waxahachie included those pictured *c.* 1882 on the north side of the square. To the far left, on the white building at the corner across the street, all that is visible is "Trippet." Those included in the row of buildings, from left to right, are J. C. Morris Groceries, H. W. Trippet Dry Goods, I and L Cerf Groceries, B. G. Connor Drugs and Groceries, a restaurant and bakery, and a saloon. To the left of the wagons, pulling the year's cotton harvest through the square, is a line of the fencing that surrounded the county's third courthouse. (Courtesy of Ellis County Museum.)

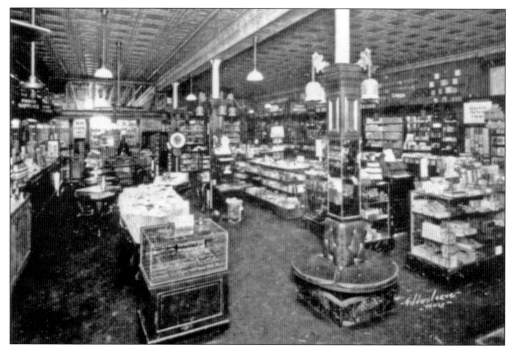

The Curlin Drug Store, pictured above, opened c. 1913. Located at the corner of North College and Main Streets, it was advertised as the "finest drug store south of St. Louis." The store was owned and operated by Lemuel "Lem" Calvert Curlin. (Courtesy of Ellis County Museum.)

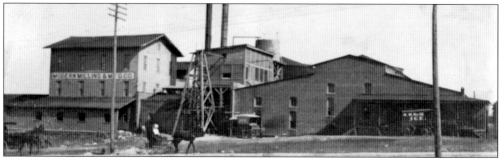

The Modern Milling and Manufacturing Company, pictured above c. 1900, also provided ice for the residents of Waxahachie. One of the company's ice carts can be seen on the right-hand side of the photograph. The company, established in the early 1890s, was located on far South Rogers Street near the railroad. (Courtesy of Ellis County Museum.)

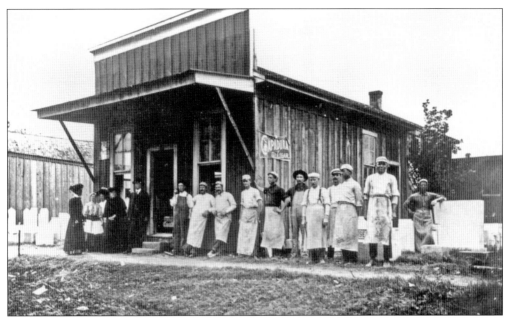

Employees of the Waxahachie Marble and Granite Company are pictured *c.* 1900. At the far left, marble headstones, designed and manufactured on site, can be seen. The facility at South Jackson and East Jefferson Streets included a stone cutting area and office building as well as a marble works building. Originally owned by the Youngblood family, it was later taken over by the Montgomery family. (Courtesy of Ellis County Museum.)

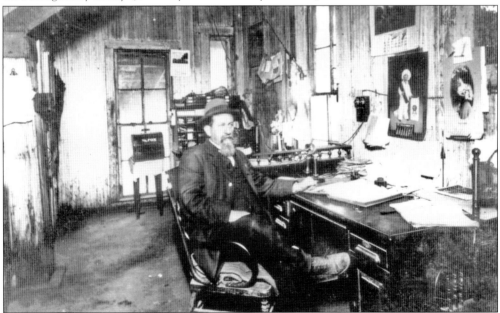

J. J. McQuatters (Joseph Judson) is pictured in his office *c.* 1911. A longtime Ellis County resident, McQuatters arrived in Waxahachie in 1876. Over the years, he was a First National Bank employee, had a horse and mule business, and was involved in the grocery business. He was also a member of the public school board for over 20 years. He and his family resided at 501 Ferris Avenue. (Courtesy of Ellis County Museum.)

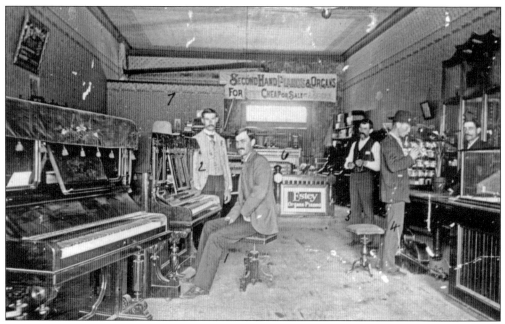

The Arnold and Pettit Music Store of Waxahachie, later known as the C. A. Arnold Music Store, pictured above c. 1890, was a full-service facility. Located on the west side of the square, the store had additional space in the back and to the side of the building where instruments could be repaired. C. A. Arnold came to Waxahachie in 1874 and shortly after married Emma Hawkins. He and his family lived for many years at 204 South Hawkins Street. Trained as a farmer, Arnold became a music dealer with his own establishment and also in partnership with B. T. Pettit. McDade Drugs, pictured below c. 1915, was located on the south side of the square and owned by druggist Thomas J. McDade. (Both courtesy of Ellis County Museum.)

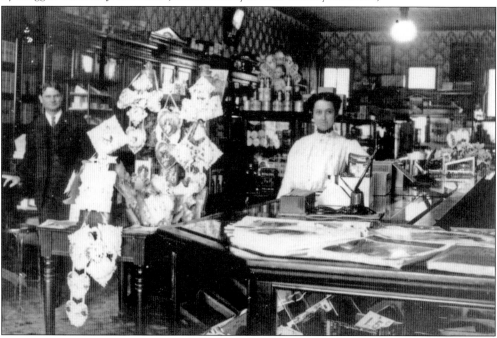

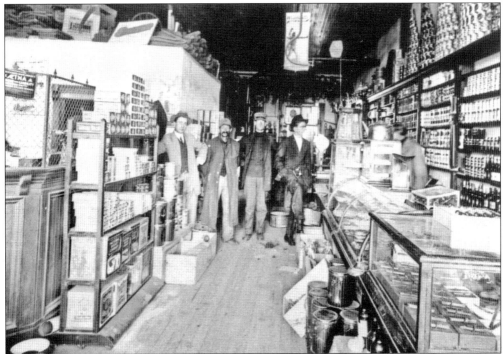

Pictured above is one of the many general merchandise stores that could be found in Waxahachie in the first decades of the 1900s. The R. S. Middleton Grocery Store, believed to have been located along East Main Street, is pictured below c. 1921. The owner of the store, R. S. Middleton, is pictured to the far left of the photograph, and the young boy pictured to the left of the produce in the middle of the photograph is Robert Henry Middleton. (Both courtesy of Ellis County Museum.)

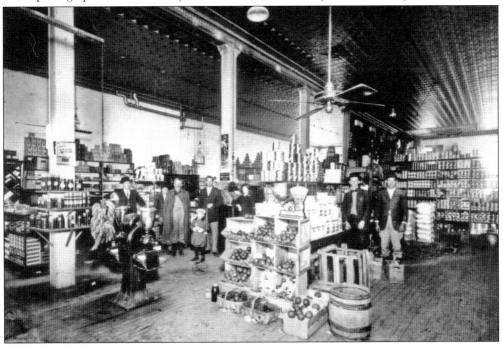

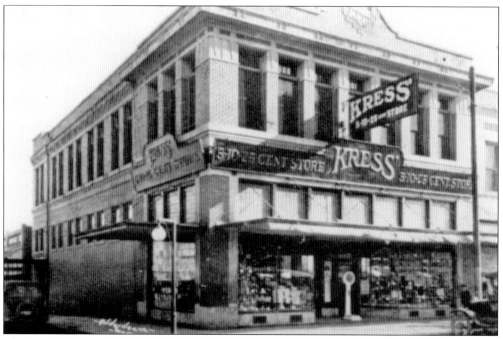

The Kress 5-10-25 Cent Store, pictured above *c.* 1918, was located on the east side of the town square at the corner of Main and College Streets. Kress was an early chain of stores that began operations in the United States in 1896 by Samuel H. Kress. Found in many U.S. cities, the store chain was known for the detailed architecture of the buildings Kress chose for his stores. Queen Theater was located on Rogers Street on the west side of the square. Pictured below, with Adele Geddes in the center, the theater advertised that the program changed daily. The current programs offered were *Victim's Vanity* and *Criminology and Reform*, the latter of which was produced *c.* 1914. The Dixie Theater was also in operation at this time, located on the north side of the square. (Both courtesy of Ellis County Museum.)

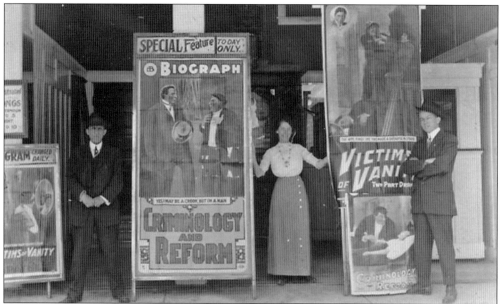

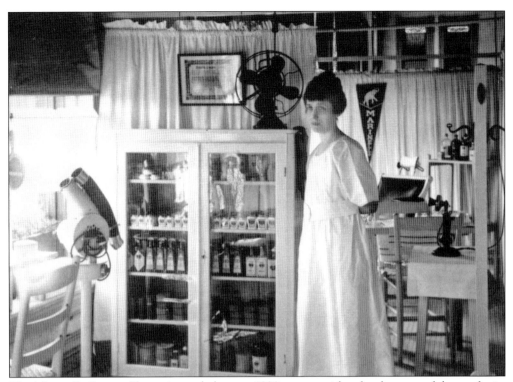

The Marinella Beauty Shop, pictured above *c.* 1920, was considered to be state of the art for its time. Located at 207 West Jefferson Street, it was operated by Adele Geddes in the 1920s. The C. C. Douglas Barber Shop, pictured below, was located at 108 East Franklin Street, behind the Ellis County Museum located at 201 South College Street. Pictured standing, from left to right, are Paul Chalmers, T. B. Chalmers, C. C. Douglas (owner), and J. D. Moore (shine attendant). (Both courtesy of Ellis County Museum.)

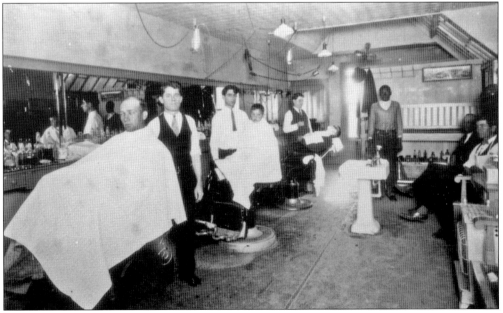

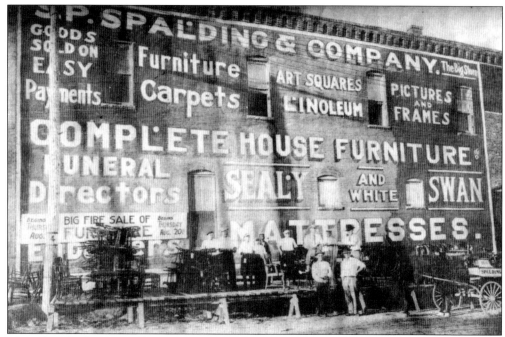

The sidewall of S. P. Spalding and Company, pictured above c. 1905, advertises their business, which included furniture sales, undertaking, and funeral directing. Pictured below is Spalding Furniture to the left and Spalding Funeral Director at the right. Many of the company vehicles and employees are seen along the front of the businesses. (Above, courtesy of Ellis County Museum; below, courtesy of Peggy Spalding.)

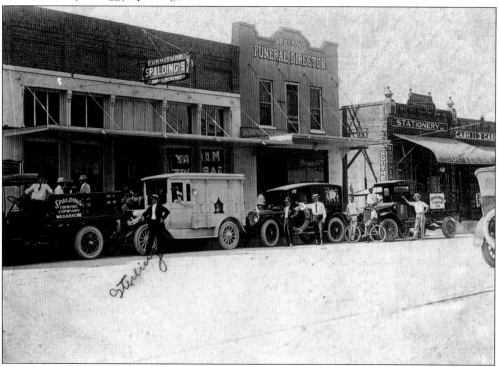

William B. Howell owned Howell Hardware, located near South Rogers and Madison Streets, pictured above c. 1912. Guaranty State Bank, pictured below in the 1920s, was located in the square on the corner of Rogers and Franklin Streets. The bank is believed to have begun operations c. 1913. In the window above the bank's corner door, Felder & Co. Cotton advertises their offices. (Both courtesy of Ellis County Museum.)

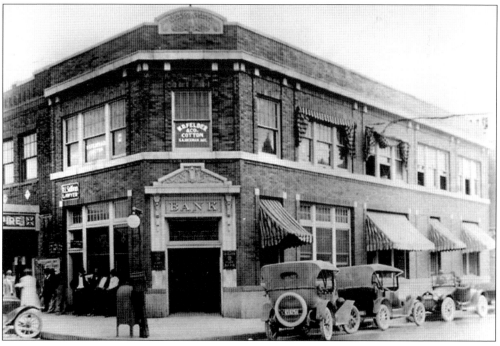

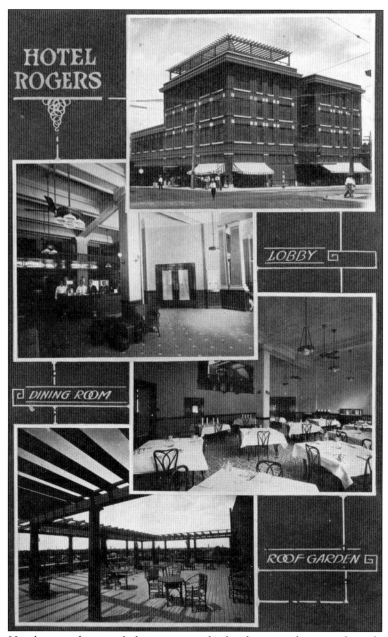

The Rogers Hotel sits on the site of what was once the first home in the city, a log cabin owned by Emory and Nancy Rogers. The building pictured c. 1914 was constructed to replace the first brick hotel, erected in 1882, which was destroyed by fire in November 1911. The hotel provided guests with electric lights and steam heat, and all the rooms had a telephone with service through the hotel switchboard. Some of the guest rooms even had private baths. The first floor was complete with parlors, sample rooms, a dining room (as seen above) that was served by a state-of-the-art kitchen, a lobby (pictured above), and a writing room. The hotel's basement boasted a barbershop, billiards parlor, trunk room, the boiler room, laundry room, and fuel storage room. There were dumbwaiters on every floor. The roof provided a garden (pictured above) that could be used for parties and receptions as well as an open area for tents. (Courtesy of Ellis County Museum.)

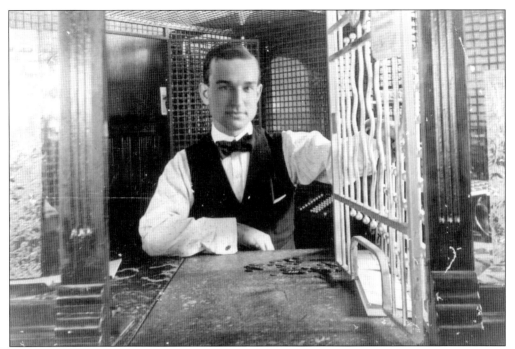

The Waxahachie National Bank was built c. 1891. Its first president was M. B. Templeton, and the first cashier was H. W. Trippet. Pictured above is Lynn D. Lasswell at his job in the teller's cage at the Waxahachie National Bank in the 1920s. The bank, pictured below, was located at the corner of Franklin and College Streets on the east side of the downtown square. (Both courtesy of Ellis County Museum.)

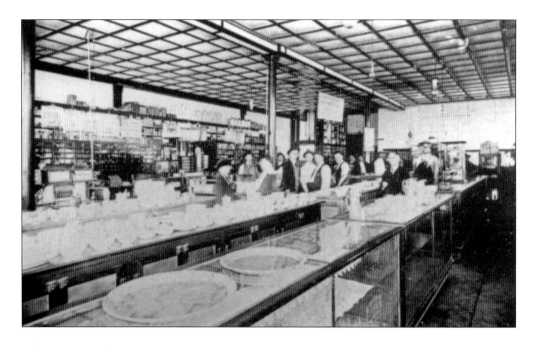

Will Moore Hardware was located at the corner of College and Jefferson Streets near the U.S. post office at that time. The store, pictured above *c.* 1910, carried a variety of hardware and household items. H.N. Nycum owned a Nycum Meat Market, pictured below *c.* 1920. The meat market was located at 106 West Main Street. In the early 1920s, Will Moore served as president and Grafton Nycum as vice president of the Retail Merchants' Association of Waxahachie. (Both courtesy of Ellis County Museum.)

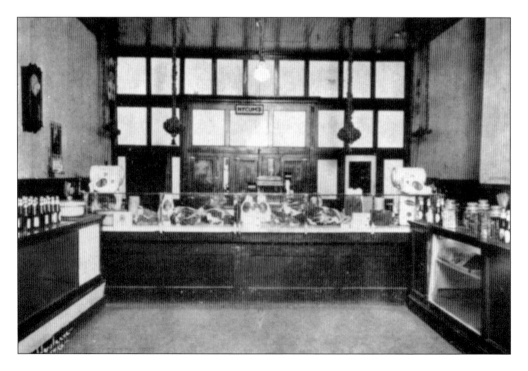

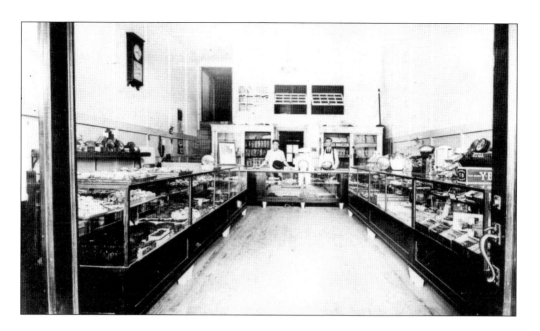

Boehle's Bakery was a busy place, providing delivery service along the streets of Waxahachie for years. Located on the north side of the courthouse square at 108 West Main Street, the bakery suffered damage in an August 1929 fire. Pictured above is the interior of the bakery c. 1920. The bakery's honey toast bread is advertised on the side of the delivery truck, pictured below along with an unidentified woman holding a selection of their products. (Both courtesy of Ellis County Museum.)

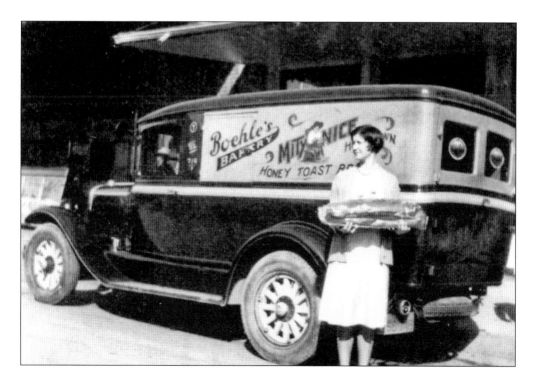

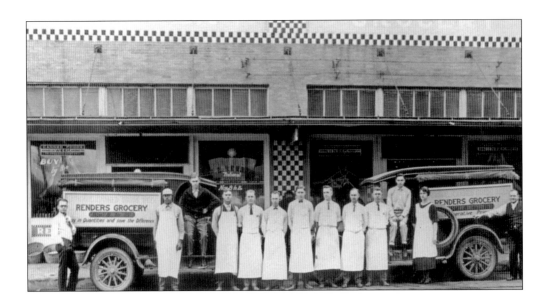

Employees of Renders Grocery are lined up in front of their store at 116 East Main Street c. 1920. A quarter of a century later, many Waxahachie residents shopped for their food at the Safeway at the corner of Rogers and Madison Streets, pictured below c. 1944. (Both courtesy of Ellis County Museum.)

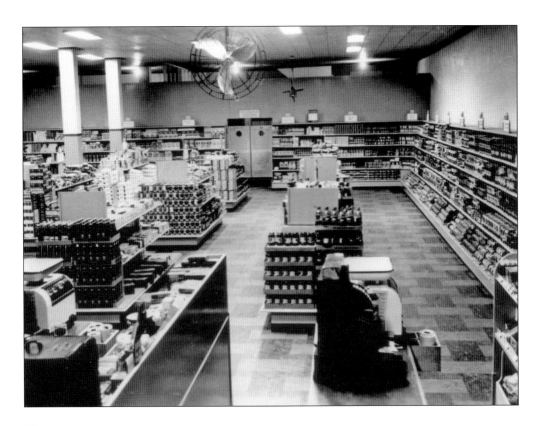

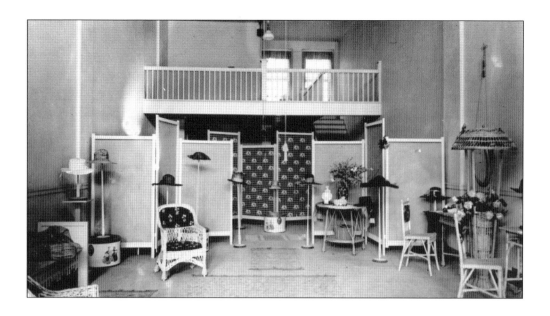

Wagenhauser Millinery, pictured above *c.* 1930, was located at 111 North Rogers Street. The shop was operated by Emma Wagenhauser and her sister Carrie. Sears, Roebuck and Company, pictured below *c.* 1940, began its history with Waxahachie in the heart of the city at its courthouse square location on the corner of Rogers and Main Streets on the west side of the square. Above, McElroy Brothers Insurance and Real Estate advertised their presence with an outdoor clock. To the left are other downtown shops, including White Auto Store, Duke and Ayres Store, and Gilliam and Upshaw Druggists. (Both courtesy of Ellis County Museum.)

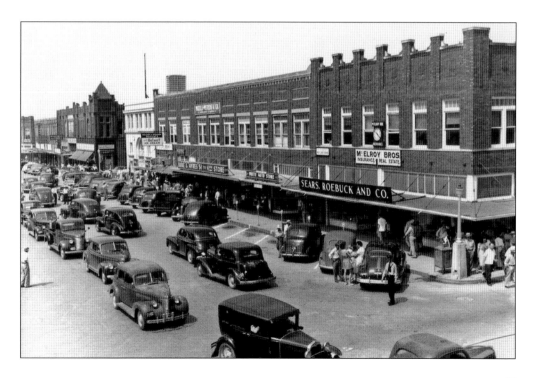

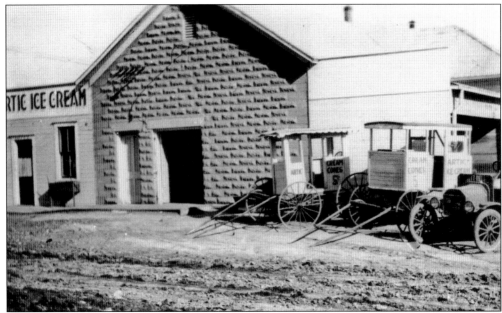

Seen at the east end of Franklin Street *c.* 1915 is the Arctic Ice Cream warehouse. To the right can be seen the company's horse drawn wagon advertising cream cones. Waxahachie boasted another ice cream manufacturer during these years. Supreme Ice Cream Factory had a manufacturing facility at 105 Water Street and a retail establishment at 109 East Franklin Street. (Courtesy of Ellis County Museum.)

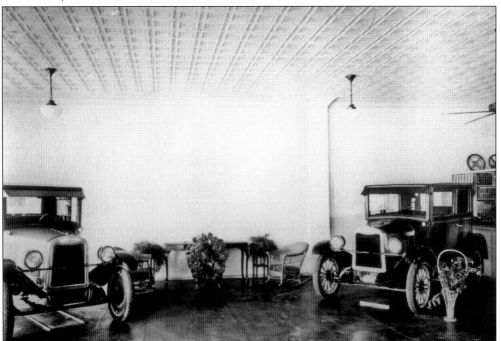

Carlisle Chevrolet opened their doors in Waxahachie *c.* 1925. The showroom, located on the corner of Elm and Jefferson Streets, is pictured with the 1926 Chevrolet models on display. (Courtesy of Ellis County Museum.)

Four

WHERE COTTON WAS KING

A tremendous amount of labor went into the effort to have the first bale of cotton each year. The sample from the first bale was what cotton buyers used to determine the grade of quality of that season's cotton crop. This set the price per pound of cotton for the year. The winner of the first bale competition was awarded prizes that could include cash and merchandise donated by area merchants. B. (Boaz) Vinson, pictured above, won the first bale competition in both 1916 and 1929. Vinson lived on the D. D. Eastham farm in Avalon. (Courtesy of Ellis County Museum.)

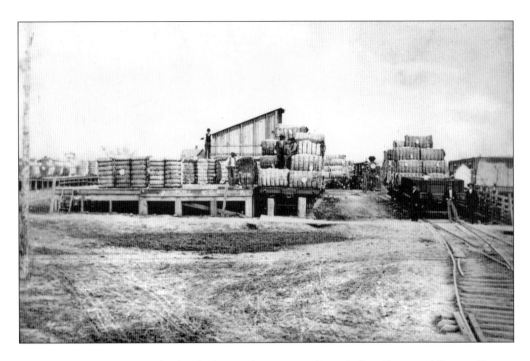

From the early years, Waxahachie had several cotton yards, including Farmers Alliance Cotton Warehouse and Yard, Fowler's Cotton Yard, and the Waxahachie Cotton Yard, pictured above *c.* 1881. Its proximity to the rail allowed for ease of shipment to the Houston and Galveston cotton merchants. Cotton bales as far as the eyes could see were a common sight in Waxahachie during harvest time, as pictured below *c.* 1914, where 10,000 bales are believed to be laid out. This compared to the only 369 bales of cotton produced in all of Ellis County in 1860. The average bale of cotton weighed 500 pounds. (Both courtesy of Ellis County Museum.)

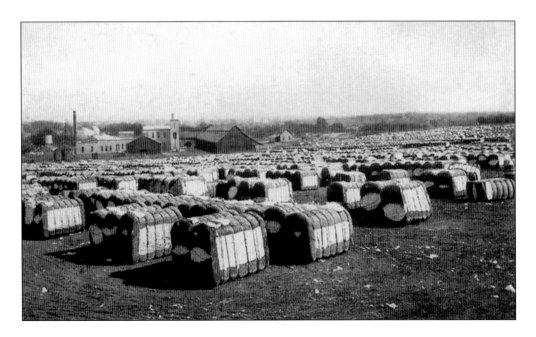

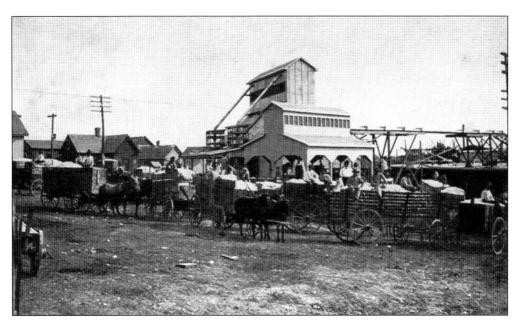

Waxahachie had several cotton gins, including Moffett and Brady Cotton Gin; the Farmers Gin, pictured above during harvest time *c.* 1905; and the Waxahachie Cooperative Gin, pictured below. A cotton gin, which was short for cotton engine, functioned to separate cotton fibers from seedpods and seeds, which could be sticky and difficult to separate manually. The gin made what was once a labor-intensive task into one that allowed for the mass production of cotton. (Both courtesy of Ellis County Museum.)

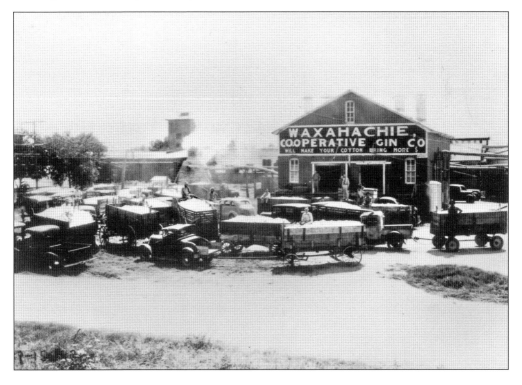

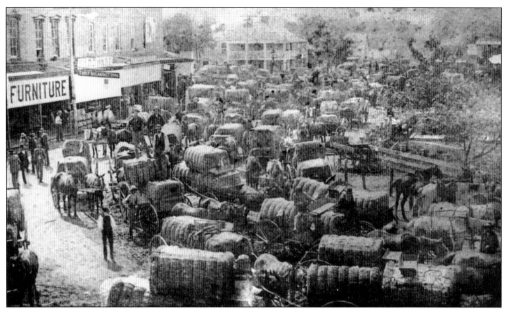

Bales of cotton can be seen as they are being transported by wagon through Waxahachie's courthouse square during cotton harvest time, pictured above *c.* 1882. The columned structure in the center and rear of the photograph is the Ellis Hotel, now the site of the Ellis County Museum, located at 201 South College Street. Cotton buyers of Waxahachie, some of whom are pictured below *c.* 1890, included Julius Brin, James Buchanan, E. R. Connell, M. F. Daniel, Will P. Edwards, W. T. Hunt, W. J. Scott, P. H. Templeton, and D. S. Tsausopulo. Many of these men worked out of the Carrick Hotel in 1890. In the 1920s and 1930s, many cotton buyers had second floor offices on the south side of the courthouse square facing Franklin Street. (Both courtesy of Ellis County Museum.)

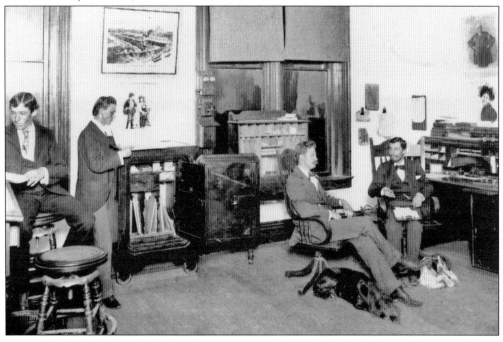

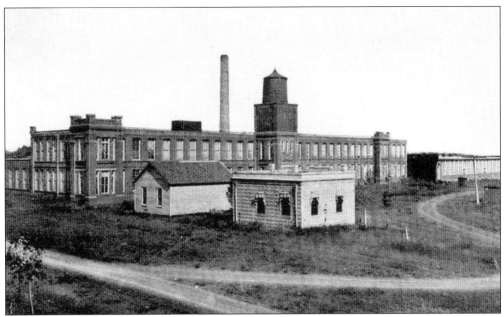

The Waxahachie Cotton Mill, pictured above, was built in 1901 with funds that were raised in large part from the citizens of Waxahachie. It was located on approximately 20 acres of land bordered by Gibson, Textile, and Circle Streets. The area came to be known as the Cotton Mill Village. This was the result of the over 20 small wooden houses that the company built as housing for its employees. The village, pictured below, also had a boardinghouse for employees. The Patrick home can be seen in the background on the right upper edge of the photograph. (Both courtesy of Ellis County Museum.)

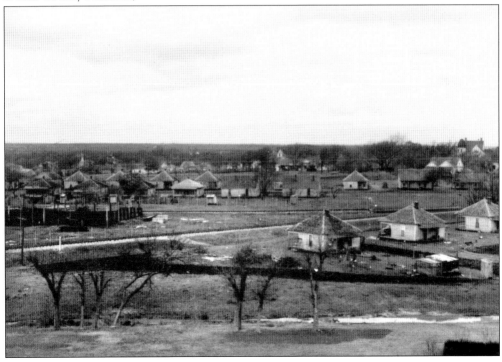

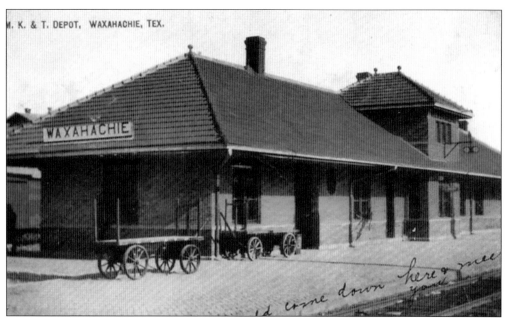

The Missouri-Kansas-Texas Railroad Depot (MK&T), pictured *c.* 1905, was located on the south end of College Street. The MK&T Railroad arrived in Waxahachie *c.* 1891 along the south side of the city. It was also known as the Katy Line. It ran from Dallas to Waco and later from Dennison to Waco. Waxahachie was one of its stops. (Courtesy of Ellis County Museum.)

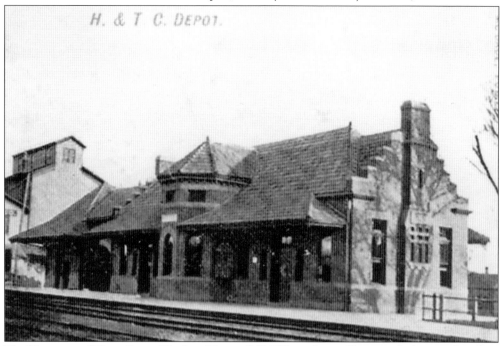

H. & T C. DEPOT.

The Houston and Texas Central Railroad Depot (H&TC) was located between Jackson and College Streets. The depot, pictured *c.* 1905, was built between 1898 and 1904. The Houston and Texas Central Railroad took over the Waxahachie Tap Railroad, which was organized by community and business leaders to bring rail to the city. (Courtesy of Ellis County Museum.)

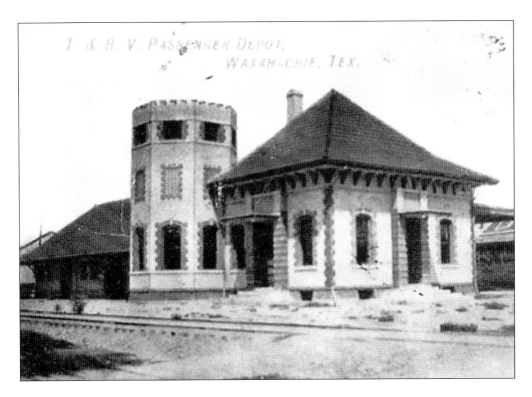

The Trinity and Brazos Valley Railroad (T&BV) arrived in Waxahachie c. 1907, connecting it to Teague, southeast of Waxahachie. Its depot, pictured above c. 1907 and below c. 1910, was located between South Rogers and South College Streets. The rear of the depot is pictured below, as viewed from South Rogers Street. (Both courtesy of Ellis County Museum.)

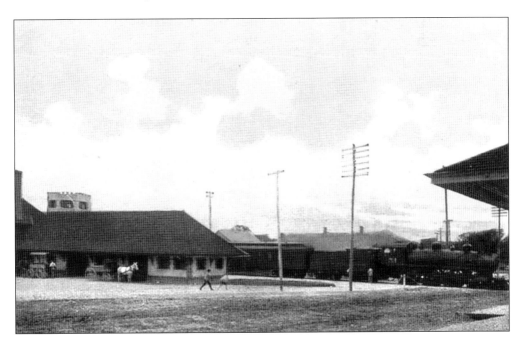

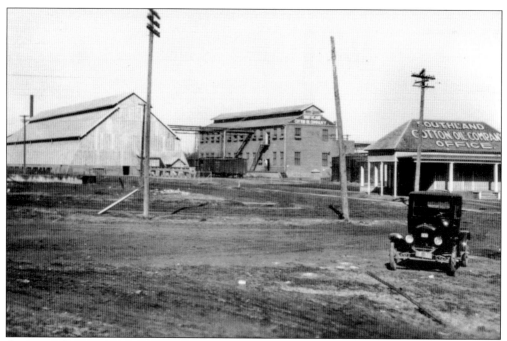

Cottonseeds were once just a by-product in the cotton industry. But by the 1880s, the potential uses for the cottonseed and its oil were known. Southland Cotton Oil Company, pictured *c.* 1928, was one of several companies in Ellis County that began operations in the late 1800s. (Courtesy of Ellis County Museum.)

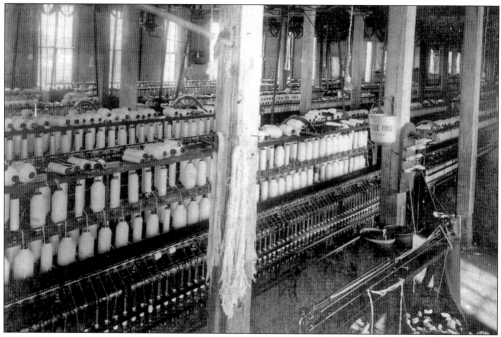

The Waxahachie Cotton Mill began operations in 1901 with 500 spindles and 150 looms. The primary product of the mill was single file ducking, which could be used for a variety of products, including awnings, sacks, and tents. (Courtesy of Ellis County Museum.)

Five

SCHOOL BELLS

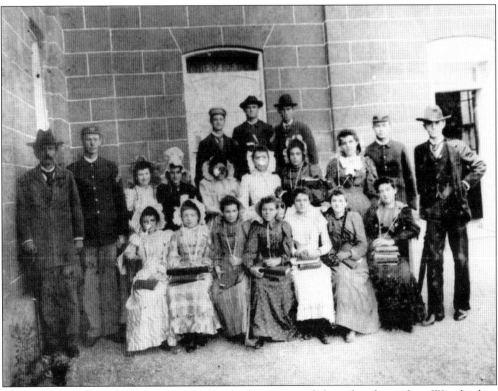

The graduating class of 1893 is believed to be the first or second class of graduates from Waxahachie. Pictured are (first row, in no particular order) Lou Allie Patterson, Lou Rainey, Elsie Wise, Maud Middleton Wilson, Minnie Redding, Fannie Lee Ross, and unidentified; (second row, seated from left to right) Mary Green Cook, unidentified, Nora Gray Lancaster, two unidentified, and Mary Browning Ackley; (third row, standing from left to right) C. M. Lyon (superintendent), A. D. Coleman, Charles Q. Barton, two unidentified, George W. Coleman, and J. Henry Phillips. In the coming years, those who were able to attend school and graduate remained a small number. In 1896, only 10 students graduated, including Gipsie Adkisson, Mattie Campbell, James Coleman, Robert Coleman, Willie Cooper, Mimia Erwin, Marcus P. McGarthy, Chas. A. Pierce, Oma Pierce, and Allie Vickery. (Courtesy of Ellis County Museum.)

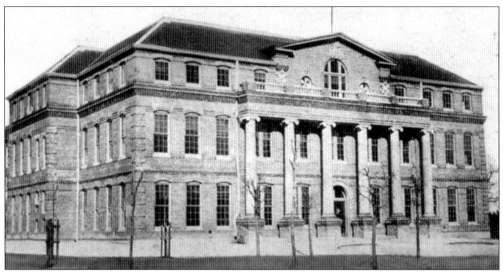

For generations, Waxahachie children have attended school at the site where the historic Marvin College once stood on College and Marvin Streets. In the late 1880s, the city's first school trustees, including C. A. Arnold, A. M. Dechman, W. B. Getzendaner, N. A. McMillan, and R. M. Wyatt, wanted to purchase the now-empty Marvin College facility for use as the city's first public school. In 1889, the city purchased the buildings for approximately $6,000. Students from outside the district could attend for a fee that ranged from $2 for elementary school to $4 for high school or college-level grades. The first teachers at Park Public School, pictured above, included Joseph Calloway, Fanny Chapman, T. B. Criddle, Mrs. N. B. Gibson, Rosa McMillan, Mrs. Tom Nash, and Mattie Young. Pictured below is the 1910 graduating class from Park Public School. (Both courtesy of Ellis County Museum.)

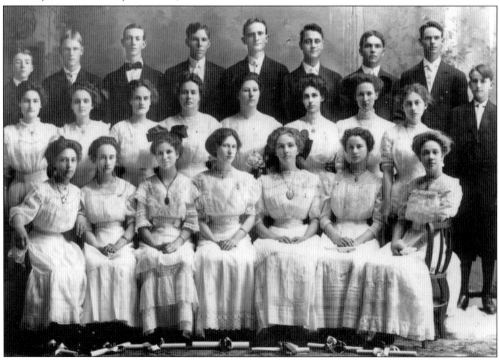

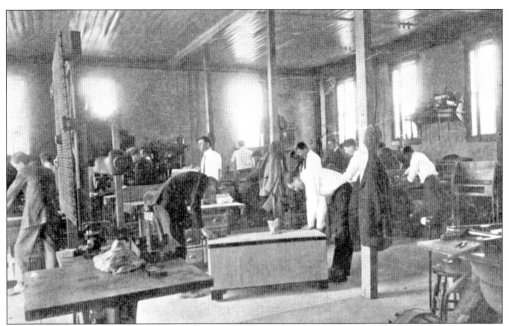

Students of Waxahachie High School had a strong academic program that included a manual training class for the boys, as pictured above, and a domestic science class for the girls, pictured below, both *c.* 1914. It was also during the 1913–1914 school year that students of Waxahachie High School published their first yearbook, called the *Waxahachie High School Annual*. For many years after that first year, it was called the *Waxahachie High School Cotton Boll*. Beginning in the 1950s and continuing through today, it has been called *The Chief*. Other activities students participated in included the Atheneaum Society, the Erisophian Literary Society, and the Philo Society. The Erisophian Literary Society was organized in December 1913 by H. S. Lattimore, and by the end of its second year, it had over 40 active members. (Both courtesy of Ellis County Museum.)

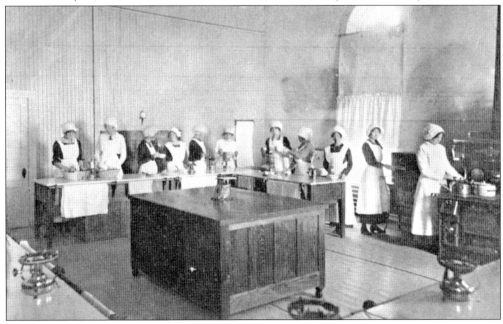

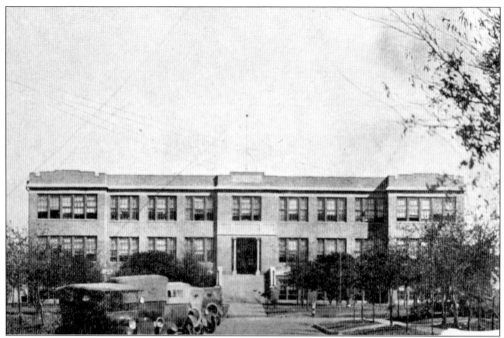

By 1922, the first students to complete their high school studies in the new Waxahachie High School wrote, "Student self government and the erection of a joint gymnasium and manual arts building on the WHS campus are actualities which we see in the mirage of the future for Waxahachie High and we, who are soon to become alumni, fervently hope that it shall be in the near future." (Courtesy of Ellis County Museum.)

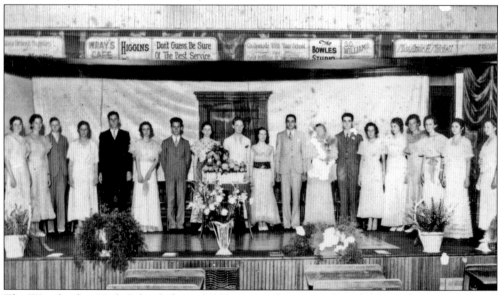

The Waxahachie High School class of 1933, pictured on stage from left to right, are Myra Dell McMurry, Mary Morrell, Myron Major, Lola Dee Tosh, R. C. Johnson, Louise Wright, Whitfield Griffing, Sara Alice Howard, Roland Parker, Cecil Dawn Webb, Wilson Wagner, Diane Nuwell, Grover Couch, Elizabeth Crumpton, Margarite Spears, Florence Morrell, Wilma Griffing, Armenia Armen, and Maude Alice Goodman. (Courtesy of Ellis County Museum.)

Crowded in front of Waxahachie High School are many of the city's young students c. 1933. The school, located at Gibson and Second Streets, later became the T. C. Wilemon Junior High School and then the Wilemon Elementary School. It is currently the location of the Global High School. (Courtesy of Ellis County Museum.)

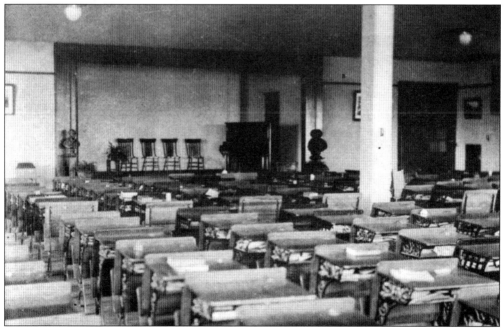

The new Waxahachie High School was completed in 1918. Pictured c. 1920 is one of its many modern classrooms. At the front of the classroom to the right is an upright piano, suggesting the room served several purposes. Within years of its completion, the school was filled to capacity. (Courtesy of Ellis County Museum.)

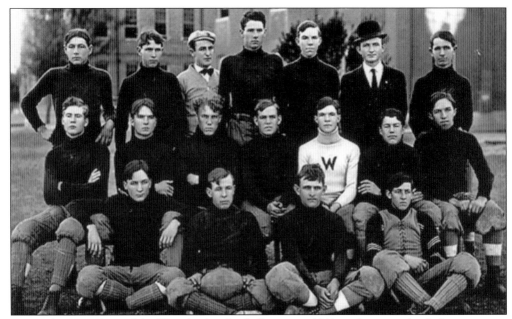

Pictured are members of the Waxahachie football team in 1911 on the grounds of what was once Marvin College, including (first row, from left to right) two unidentified, Dickie Quaite, and J. R. Shelton; (second row, from left to right) Bass Williams, unidentified, James Hurd, Ed Sweat, John Henry Pierce, George Hurd, and unidentified; (third row, in no particular order) Raymond "Bugs" Fleming, John Templeton, and five unidentified. (Courtesy of Ellis County Museum.)

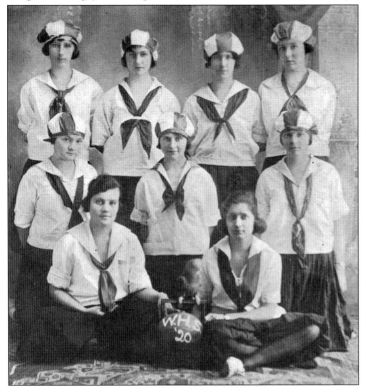

In 1920, the girls' basketball team won three of the four games they played, losing only to Midlothian. The games won were against Buena Vista, Rockett, and Ferris. Their team members included Mildred Daniel (guard), Frances Dunaway (forward), Flora Fulks (guard), Mary Hildebrand (forward), Elizabeth Kilbourne (center), Callie Morris (center), Alda Morton (center), Allen Wakeland (guard), Alta Waters (forward), and their mascot, Polly. Waters was also their team captain. (Courtesy of Ellis County Museum.)

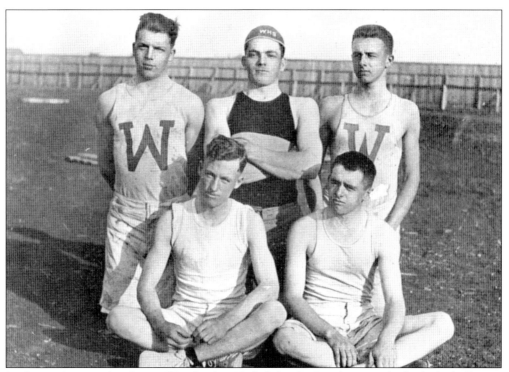

In the 1916–1917 school year, Waxahachie High School's Coach Moore had a basketball team comprised of players that, according to the yearbook, "were hard to beat." In addition to winning several important games, they also won the county championship. Pictured above are the members of the basketball team that year, including B. Winn (forward), Fred Hunter (forward), Lane Finley (guard), Tom Winn (guard), and Bill McCluney (center). Pictured below is the 1924 high school track team. (Both courtesy of Ellis County Museum.)

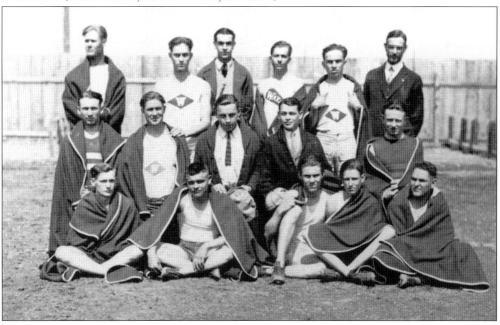

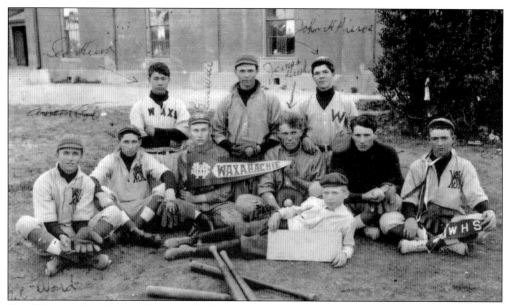

The Waxahachie High School baseball team of 1911 is pictured above, including, from left to right, (first row) an unidentified bat boy; (second row) Estel Word, unidentified, L. Lasswell, James Hurd, Raymond Fleming, and Anson Cole; (third row) George Hurd, unidentified, and John Pierce. Members of the Waxahachie school band c. 1930 pictured below, from left to right, are (first row) Billie Pitts, Roger Frank, David Fox, Jim Fox, Jr. Myers, W. Boehle, Chapman Middleton, and James Lawrence; (second row) Richard Ford, Robert Middleton, Charles Morse, R. E. Nix, George Fulton, Billy Sims, Sterling Ball, Barney Wray, Irene Keplinger, and John Fulton; (third row) Violet Dortsch, Howard Rutherford, Jack Sims, Logan Dietz, Wilton Whitefield, Marvin Borders, Tom Curlin, and Clovis Mitchell; (fourth row) Billy Morris, Jack Herrington, Jack Curlin, J. W. Moffett, Jack Middleton, Jack Hickman, and W. A. Plumhoff; (fifth row) Jo Garvin, Edna Whitefield, and Dorothy Few. Band mascots Raymond and Ralph Frank are in the forefront. (Both courtesy of Ellis County Museum.)

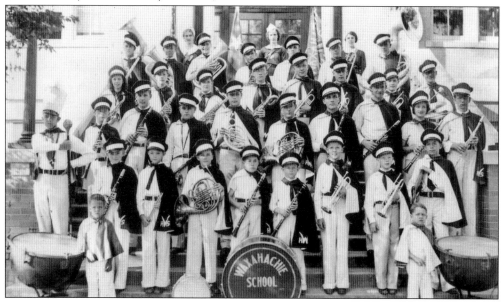

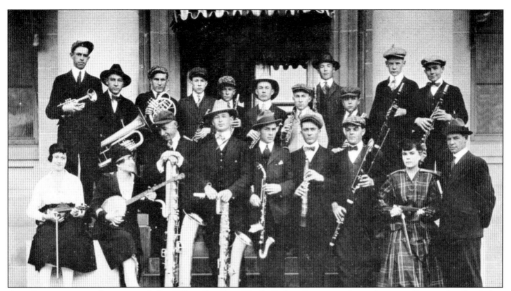

Academics were the core of the Waxahachie High School curriculum, but students also had the opportunity to participate in various cultural activities, including music and theater. Pictured above is the school orchestra in 1917. The senior class of 1924 performed *The Charm School*, a scene from which is pictured below. It told the story of a young automobile salesman who inherited an all-girls school. When tryouts were held, judges selected those who would play the five main characters, and a committee selected who would fill the remaining characters. Among those students performing in the play were Jennie Ruth Chapman, Opal Connally, Angie Fleming, George Hinkle, Margaret Howorth, Dorothy Kemble, Ethel Martin, George Edwin McWhirter, Stanley Mitchell, Bobby Ownby, Herbert Peters, Lynton Powell, Annie Lee Stovall, Goodwyn Sweatt, Tiny Whitaker, and Gladys Whitley. Lucile Bennett, Mrs. Harry Fugate, and Yetta Mitchell directed the play. (Both courtesy of Ellis County Museum.)

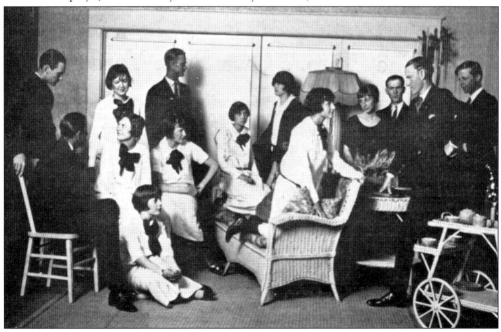

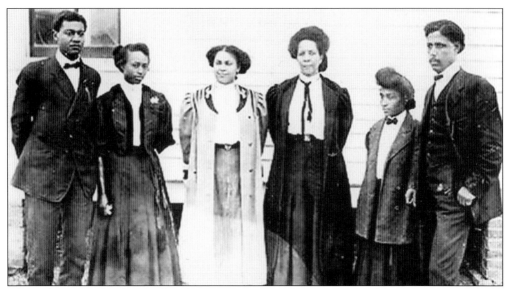

The Oak Lawn School opened its doors in 1887 as an elementary school for African Americans. Students met in a one-room building until 1893, when the school was moved to a small building on Wyatt Street. In 1899, two boys and two girls comprised the first graduating class from Oak Lawn High School, including Prince Goldthwaite and Robert Davis. Both returned to Oak Lawn as principals and are pictured above with other faculty of the school c. 1910. From left to right are Robert Davis, Corine Burnett, Anita Richard, unidentified, Mrs. Goldthwaite, and P. E. Goldthwaite. Pictured below are members of the faculty c. 1925. From left to right are (first row) Ola May Goldthwaite, Robert Davis, and Lucille Davis; (second row) Mary "Miss Doll" Porter, Lessie Blanton, and two unidentified; (third row) two unidentified, Ed Lee Gibson, and two unidentified. (Both courtesy of Ellis County Museum.)

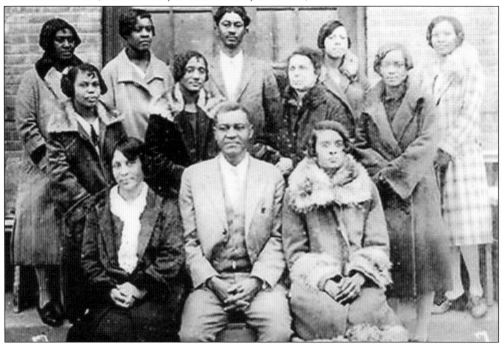

Oak Lawn High School's principal, J. W. Tilden, is pictured with the first graduating class of the school c. 1899. Tilden is pictured above in the center between Prince Goldthwaite (left) and Robert Davis. The identities of the graduating girls are unknown. Pictured below in their caps and gowns is the Oak Lawn High School graduating class of 1930. They include, from left to right, (first row) Robbie Davis, Lillian Graves, Lucille Howard, Willie Barton, and Willie Mitchell; (second row) Ruthie Washington, Jettie Howard, Geneva Scruggs, Ruby Pharms, Zenobia Saunders, Harvey Edwards, Irving Williams, Ethel Britt, William Cade, and Grace Rainey; (third row, center, sitting on unseen banister) unknown Hereford and Naomi Higgins. (Both courtesy of Ellis County Museum.)

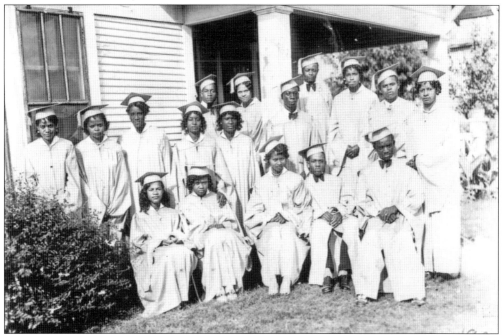

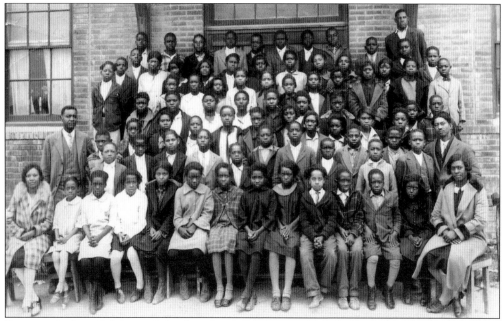

Posing with their Oak Lawn School students in 1926 are Robert Davis (second row, far left) and Ed Lee Gibson (second row, far right). Davis was a member of the first graduating class of Oak Lawn School. He returned later to teach math and served as a principal at the school in the mid to late 1920s. (Courtesy of Ellis County Museum.)

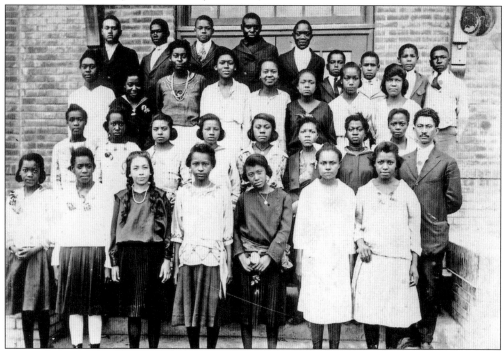

Pictured at the far right of the second row with his Oak Lawn School class c. 1920, is Ed Lee Gibson, a teacher at the school. Gibson taught the manual training class in the basement of the school, where the Manual Training Center was located. (Courtesy of Ellis County Museum.)

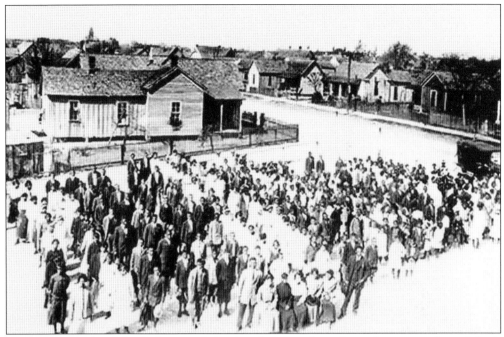

The student body of the Oak Lawn School included students from elementary through high school. Pictured above is the school's student body *c.* 1915 in a photograph taken from a window of the school located on Wyatt Street. Only a few years later, during Prince Goldthwaite's tenure as principal, new classes were added, including manual training courses for boys and homemaking classes for girls, such as the sewing class pictured below *c.* 1920. Goldthwaite's wife taught the home economics classes at the school, including the one below. (Both courtesy of Ellis County Museum.)

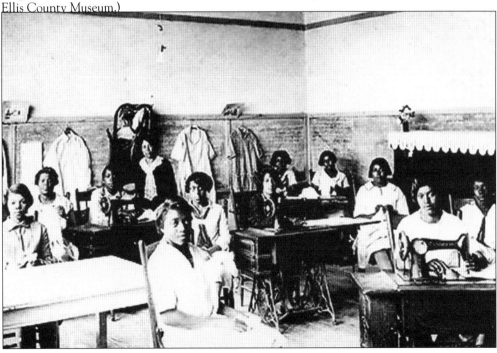

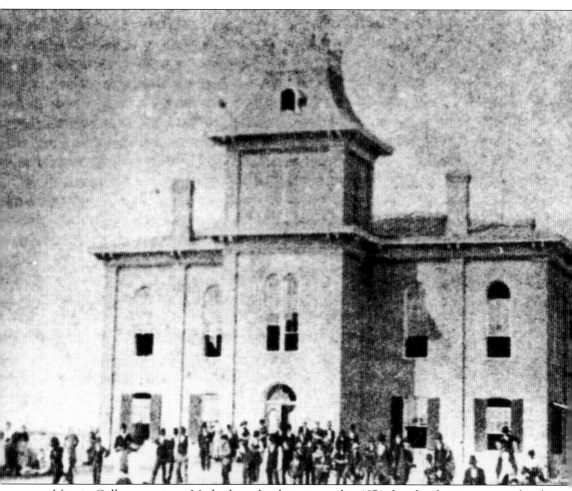

Marvin College, a private Methodist school, is pictured *c*. 1871 shortly after it was completed. The school was named in honor of Bishop Enoch M. Marvin of the Trans-Mississippi Conference of the Methodist Episcopal Church, South. Among the presidents of the school were Rev. J. W. P. McKenzie, Rev. J. M. Pugh, Dr. M. B. Franklin, Rev. John R. Allen, and Gen. L. M. Lewis. In 1876, tuition for a five-month session at Marvin cost from $10 to $25 and room and board could run from $12 to $15. The last commencement at the school was held in 1884, after which the building and land were sold to the City of Waxahachie in 1889 to be used as a public school. (Courtesy of Ellis County Museum.)

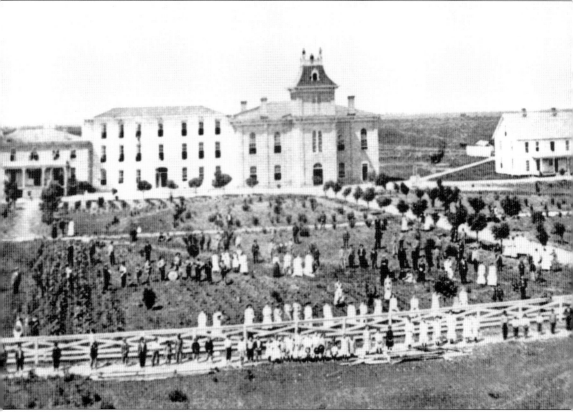

Marvin College grew to an enrollment of approximately 160 students in the 1877–1878 school year. The school provided primary, preparatory, and collegiate education to its students. The first floor housed six recitation rooms and a large study hall area. The second floor was a chapel that could seat 800. To the west of the campus, pictured c. 1880, was a two-story building with a rounded roof that housed an observatory as well as a laboratory on the first floor. In the school tower was a bell, given to the school by New York City merchants, which could be heard over 5 miles away. College activities included a band, newspaper, alumni association, and a music department. (Courtesy of Ellis County Museum.)

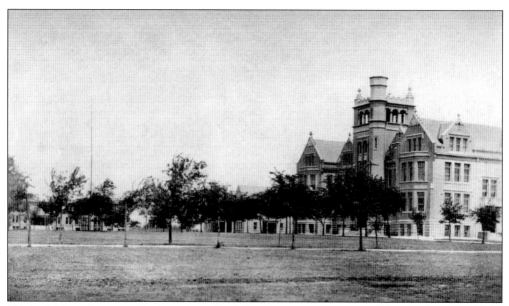

Trinity University was a Presbyterian school that began operations in Waxahachie in 1902 on Sycamore Street. Relocated from Tehuacana, where it had been founded in 1868, the school eventually included numerous buildings, including the main building, pictured above at the right, a girl's dormitory that was added to the campus in 1911, and a gymnasium in 1926. The university closed in 1942 when it was relocated to San Antonio. Around 1944, the Southwestern Bible Institute, which later became the Southwestern Assembly of God College, moved into the Trinity University campus. Still a landmark of the city, the institution is now known as Southwestern Assembly of God University. The university auditorium, pictured below, could seat up to 600, including balcony seating. (Both courtesy of Ellis County Museum.)

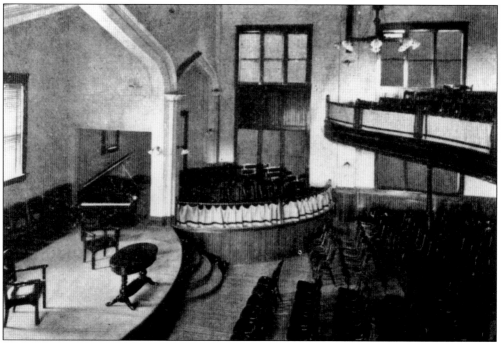

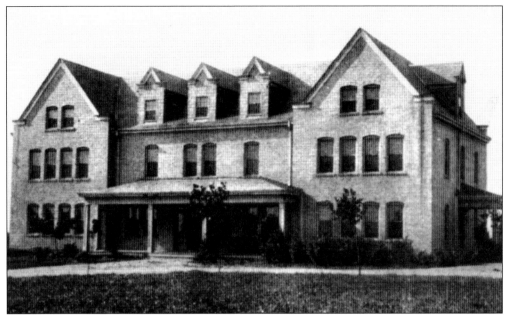

Trinity University campus included many stately buildings, including the Pendergast Conservatory of Music, pictured above. The Beeson Dormitory Hall for Men, built in 1906, was named for the university's first president, Dr. W. E. Beeson, and is pictured below. The campus also housed women in the Drane Hall for Women. In the latter part of 1929, a fire completely destroyed Beeson Hall, and early records show the destruction took place in less than an hour. The fire reportedly began in a trash chute in the early part of the day while most students were at breakfast. Three students—J. D. Hampel of Palmer, Don May of Leonard, and Henry Moore of Hubbard—were trapped on the third floor of the residence building before being able to escape safely. (Both courtesy of Ellis County Museum.)

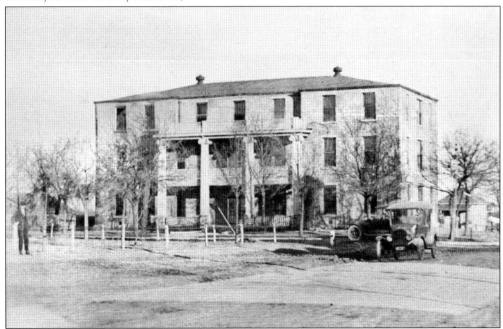

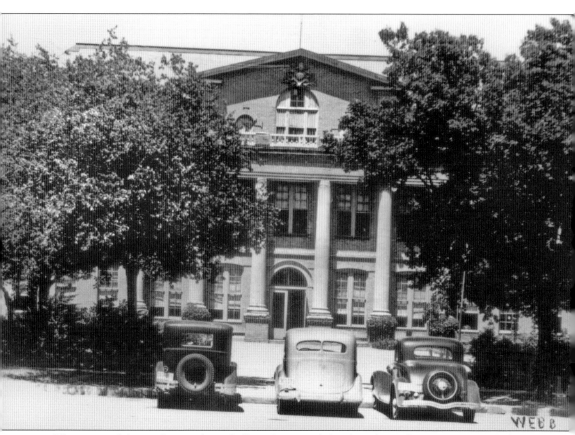

The area on Marvin Street where College Street ends has long been the cornerstone of education in the city. It was first the site of Marvin College in 1871 and provided an education to many in the area until it was sold to the City of Waxahachie because of financial difficulties. Then known as Park Public School, it provided an education to students from elementary through college level. It later became known as the Waxahachie Public School. A new three-story building was constructed in front of the section of the old Marvin building facing College Street with a covered pathway connecting the old with the new. The school continued at this time to house first grade through high school levels. The third floor housed not only the high school classes but also an assembly hall and a study hall. By 1911, other schools were being built in Waxahachie, including Ferris Ward and South Ward in Bullard Heights, taking some students away from Park Public, now known as Central Ward. (Courtesy of Ellis County Museum.)

Six

PLACES OF FAITH

In 1849, at the home of Maj. E. W. Rogers, the First Methodist Episcopal Church was organized. Their first church home was built in 1851 on a lot donated by Rogers on what would later become East Franklin Street. It was made of wood and measured only 16 by 20 feet. It was destroyed by fire within years. Undeterred, the small congregation built another church, also on Franklin Street, just to the west of where their first place of faith had stood. This structure was under construction for two years. Dedicated in 1856 by Bishop Robert Paine, this small church on East Franklin Street, pictured at right, provided a home for its Methodist congregation as well as a place of worship for several other denominations, including the Baptist and Presbyterian congregations of the area. Among the first members of the Methodist congregation included C. H. Barker, Margaret E. Barker, Rebecca A. Barker, D. P. Fearis, Jonathan E. Price, Vetura Prince, E. W. Rogers, Nancy Rogers, Milley Weaver, and N. H. Whitenberg. (Courtesy of Ellis County Museum.)

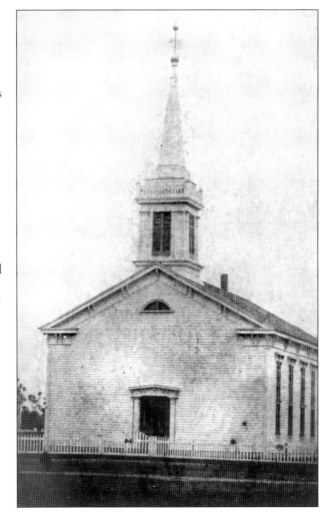

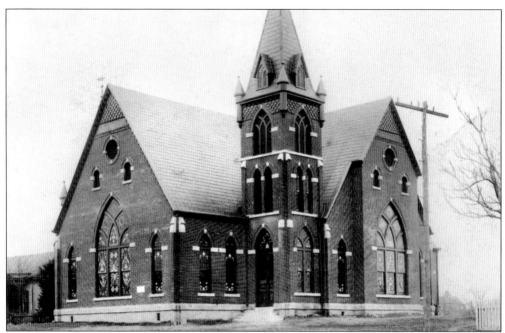

In the early 1890s, the Methodist congregation built the new church pictured above on College Street. In November 1904, like their first church, the brick structure was completely destroyed by fire. They rebuilt at the same location, pictured below, and had their first service in the new church in 1905. This was home to the congregation for almost half a century. When a new church was built on Marvin Street in the early 1950s, many of the stained-glass windows and the pump organ, obtained to replace those lost in the 1904 fire, were taken with the congregation to be used in the new church. (Both courtesy of Ellis County Museum.)

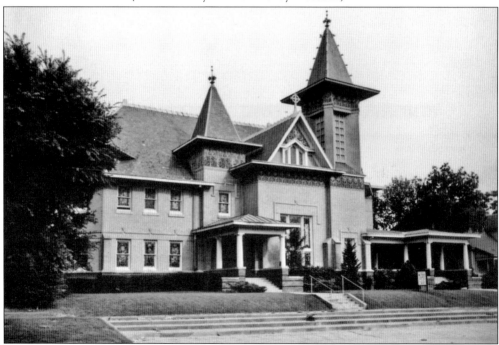

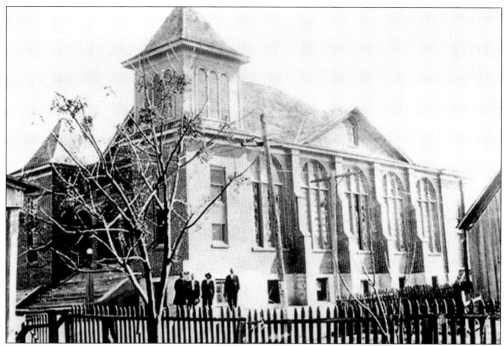

The Joshua Chapel African Methodist Episcopal Church was organized c. 1866, first meeting in an old farmhouse miles outside of the city and later at a schoolhouse building on Aiken Street in Waxahachie. The early members of the congregation named their church in honor of Rev. Joshua Goins, who organized many of the first African Methodist Episcopal churches in the state. In 1917, they built the church pictured above on land purchased in 1879 by Rev. Monroe Conner, Rev. Joshua Goins, and Rev. M. Lowe for $300 from Cyrus Aiken. Noted architect W. S. Pittman, who was educated at Tuskegee Institute and Drexel Institute, designed the structure. Standing in front of the church are many of its members, pictured below in the 1920s, including the presiding elder Jenkins and Reverend Reed. (Both courtesy of Ellis County Museum.)

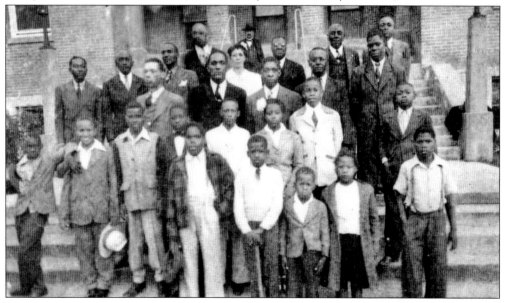

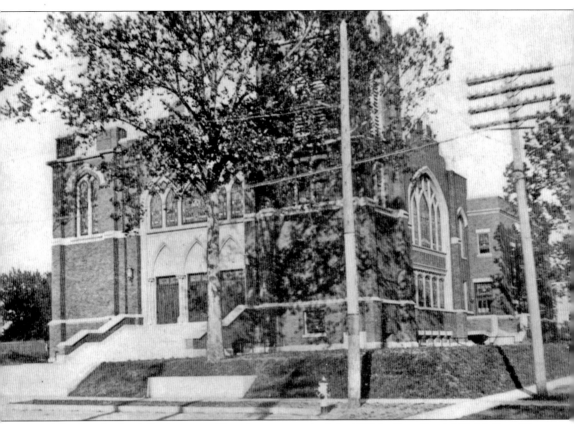

The Cumberland Presbyterian Church was organized in 1853 by Rev. Daniel G. Molloy. They met first in an old schoolhouse building and then the Methodist church before constructing their church on the northeast corner of Elm and Main Streets. In 1892, with a growing congregation, the church built a new place of worship at College Street and Oldham Avenue. A quarter of a century later, the congregation raised the funds, over $100,000, to build a new church at the same location at 402 North College Street, pictured above in the early 1920s. (Courtesy of Ellis County Museum.)

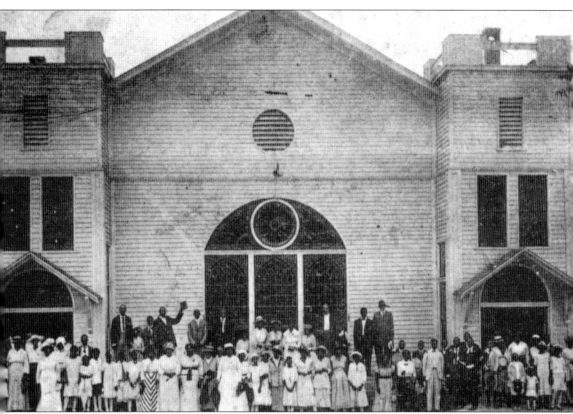

The Samaria Missionary Baptist Church was first organized in November 1864. Their first place of worship was on the site across from their current church at 508 East Main Street. Rev. D. Biggins first organized it with the help of members of the Mount Horeb congregation. Their pastors have included Rev. H. Brown, Rev. Darron L. Edwards, Rev. Hill, Rev. W. A. Joshua, Rev. S. M. Mitchell, Rev. G. B. Prince, Rev. S. H. Robinson, Rev. J. R. Swaney, Rev. J. A. Thomas, Rev. K. K. Wells, and Rev. Tony Williams. (Courtesy of Ellis County Museum.)

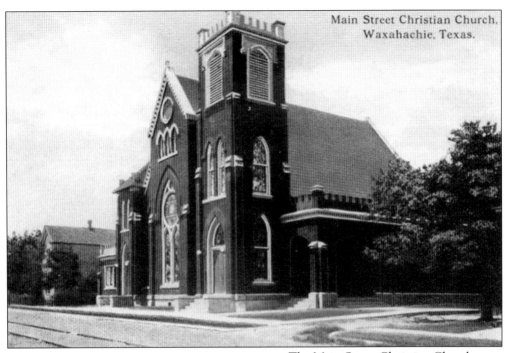

The Main Street Christian Church was organized in 1878. Their church building was constructed in 1892 at 408 West Main Street. In 1911, the congregation built a new church, pictured above, erected by local contractor C. J. Griggs. (Courtesy of Ellis County Museum.)

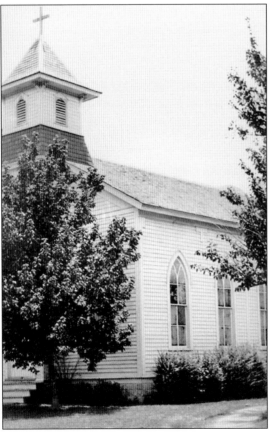

Fr. Claude Marie Thion organized St. Joseph Catholic Church in 1874. In 1875, he conducted the first mass in their first church building that had approximately 20 members. Pictured is their second church, dedicated in August 1892, located on East Marvin Avenue at the same site as the current St. Joseph Catholic Church at 512 East Marvin Avenue. (Courtesy of Ellis County Museum.)

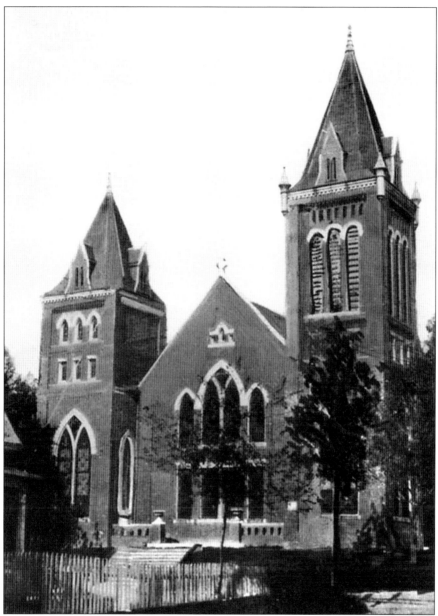

The First Baptist Church was organized in 1861. Early meetings were held at the Methodist church until their first church home was built in 1882 at a cost of $5,000. Early members included Jane ?, N. G. Davis, A. A. Foster, N. B. and Margaret Langsford, William H. and Adeline Roberts, Mary E. Spalding, N. G. and Isaphine Wise, and Robert M. and Amanda R. Wyatt. The first pastor of the church was W. H. Stokes. Other early pastors included Josiah Leake and E. H. West. Early officers of the church included A. S. Farley, Sunday school superintendent; Dr. J. A. Gracey, treasurer; and S. P. Skinner, clerk. In the late 1890s, having outgrown their small frame church with a congregation well over 200 members, a new church was planned. Built at the same location at Rogers and McMillan Streets, it was completed c. 1899. This new church, pictured above c. 1918, served the congregation for almost five decades. In the late 1950s, a third church was built on the same location. Its first service was held in March 1959. (Courtesy of Ellis County Museum.)

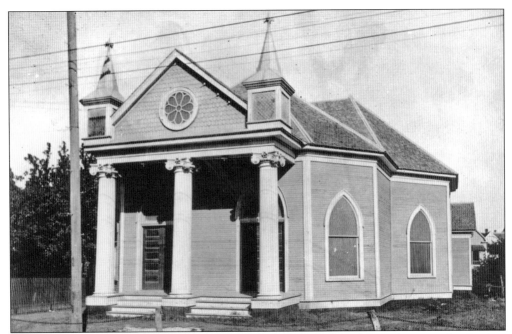

The Church of Christ was first organized in the early part of 1905. Members met for the first time in their new church, the College Street Church of Christ, pictured above in November of the same year. In 1937, plans were made for a larger church, which was completed in 1939. Members held church services in the interim at the Chautauqua Auditorium until their new church was completed. Pictured below is an outdoor baptism in the late 1800s. (Both courtesy of Ellis County Museum.)

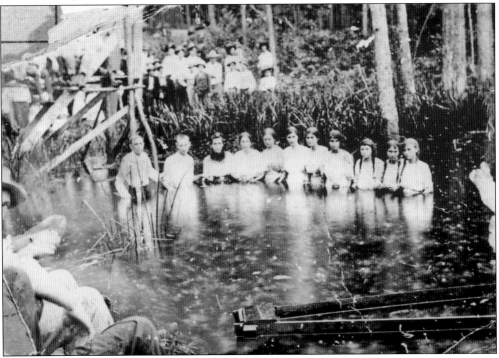

Seven

THE SHINING STARS
OF WAXAHACHIE

Bessie Coleman came to Waxahachie as a child of two *c.* 1895. With the hope of becoming a pilot, she worked and saved, and at her brother's invitation, joined him in Chicago. It was in Chicago that she met Robert Arnold, editor of the *Weekly Defender*, a Chicago paper. At his suggestion, Bessie made plans to go to France to learn to fly. Flight schools in America did not accept women. She took lessons to fly beginning in late 1920 and by June 1921, was licensed by the Federation Aeronautique Internationale, the first African American woman to become a licensed pilot. After learning the more dangerous maneuvers required for stunts and aerobatics, she returned to the United States and became a barnstormer. She earned the name "Brave Bessie" for her daredevil maneuvers. On April 30, 1926, she died during a test flight prior to a show sponsored by the Negro Welfare League in Jacksonville, Florida. (Courtesy of Ellis County Museum.)

The Waxahachie Fire Department was known as the Salamander Fire and Hose Company in the late 1800s. With little financial support, they fought fires without the proper equipment or fire hydrants. After the fire of 1882 that destroyed approximately 25 homes and 28 places of business, a committee was formed by the board of aldermen with the purpose of improving the city's protection against fire. In May 1883, funds were approved to purchase required equipment, including a Silsby Steam Fire Engine as well as hose carts and hose. While the city funded the newly formed Salamander Fire Company No. 1 in terms of equipment, the men that formed the fire department continued serving their community as volunteers through c. 1922. Firefighters are pictured with their equipment in the 1920s. (Both courtesy of Ellis County Museum.)

In 1892, the new city hall and fire station were completed on the corner of Elm and Main Streets. Prior to this, the fire department had been located at Rogers and Water Streets since c. 1883. The new facility, built on land bought from the Cumberland Presbyterian Church for approximately $2,100, included a bell tower that alerted the firefighters, who were still volunteers, that their services were needed, as pictured at right near the courthouse c. 1910. By 1925, the volunteer firefighters were now a paid department. Their equipment, some of which is pictured below in front of the city hall and fire department c. 1924, included an American La France combination pumper, a Seagrave 2-horse combination chemical and hook-and-ladder truck, and a 105-horsepower motor-driven pumping engine. (Both courtesy of Ellis County Museum.)

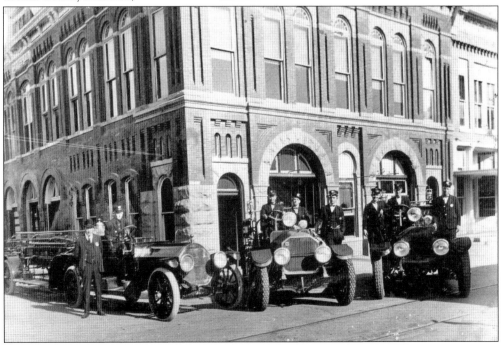

Charlie Huff, pictured above with Jimmy Gillam (right) *c.* 1936, delved into show business in the late 1920s. While in Hollywood, he worked for both MGM and 20th Century Fox Studios as both a dancer and choreographer. After the Depression, he and his wife, Jean Killebrew Huff, returned to her hometown, Waxahachie. Upon his arrival in Waxahachie, he operated a dance studio, taught horsemanship, called square dances, and later opened the doors to his riding academy. From 1949 to 1975, he served as Ellis County clerk. He is pictured below, in the center holding a mike, on the rodeo grounds of Waxahachie in the late 1940s. A renowned horseman, Huff was one of the founders of the Ellis County Equine Association (ECEA). At the ECEA's yearly awards banquet, the Charlie Huff Hall of Fame Award is presented in his honor. (Both courtesy of Ellis County Museum.)

Jovan Marchbanks tried to enlist at the beginning of World War I but was rejected. Determined to serve his country, he signed up when the draft was implemented. Assigned to the 359th Infantry of the 90th Division, he was promoted twice during training. He arrived in France as a sergeant and soon after fought in the Battle of Rheims. Within the month, during the St. Mithiel drive, he was hit in the shoulder and chest by machine-gun fire while leading his men in a charge of the enemy line. As the fighting continued around him, he was injured in the face by a nearby artillery shell explosion. Taken by the Germans as a prisoner of war, he was hospitalized. Three weeks later, he died from his wounds. Jovan Marchbanks was born in Ennis, Texas, and raised in Waxahachie, where he graduated from high school. Waxahachie grieved for the loss of one of their young men. His funeral cortege, pictured below, is seen as it makes its way down North College Street. (Right, courtesy of Perry Giles; below, courtesy of Ellis County Museum.)

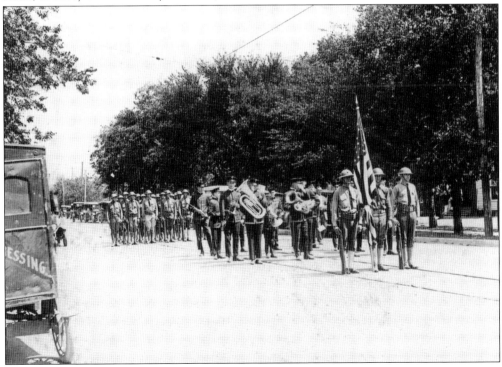

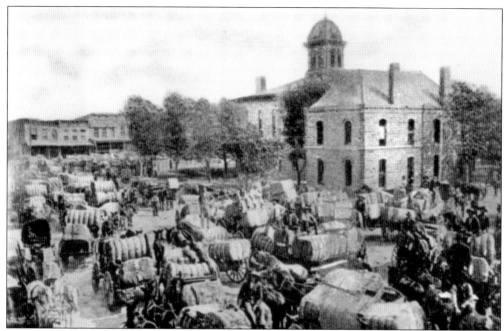

The Ellis County Courthouse has been at the heart of the city of Waxahachie from almost the very beginning. The first courthouse, a log structure brought from Dallas County and rebuilt in time for the first session of the district court in October 1850, cost the county less than $59. The second courthouse, a two-story wood frame building, was completed in 1854. Built by David P. Ferris, it cost approximately $1,999. The third courthouse was constructed in 1872. A 60-foot square detached two-story records building was added in 1887, pictured above during harvest time looking east from Rogers and Franklin Streets. Both were torn down in 1895 for the construction of the fourth and current county courthouse, pictured below c. 1915. (Both courtesy of Ellis County Museum.)

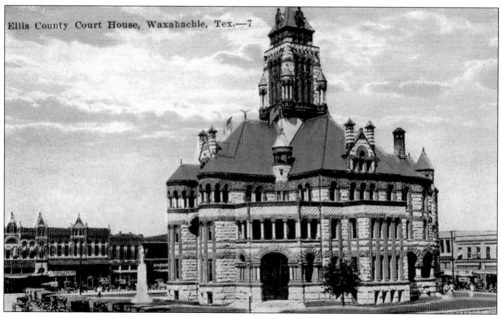

Ellis County Court House, Waxahachie, Tex.—7

The current Ellis County Courthouse, pictured on the right *c.* 1910 and below in the 1940s, was designed by architect James Riely Gordon. Fort Worth architect Marshal Sanguinet was hired as a consultant and construction supervisor. The courthouse is nine stories tall. The clock tower, now powered by electricity, is the same that provided Ellis County residents with the time over 100 years ago. The courthouse still retains much of its original interior, including some of the original judicial benches, which can still be found in its courtrooms. A bullet hole, the result of a gun fight in the 1920s that left a deputy wounded and another man dead, can still be found in a first floor office, formerly a sheriff's office. Despite being the focus of much debate over its cost in 1895, which was approximately $175,000 with furnishings, the courthouse has been the center of the county, the city of Waxahachie, and of its community for decades and will continue for decades to come. (Both courtesy of Ellis County Museum.)

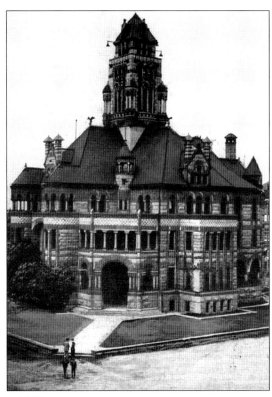

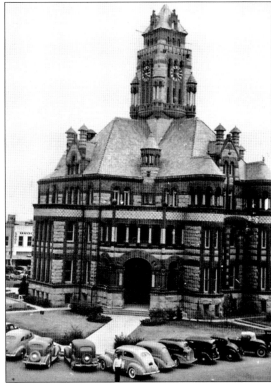

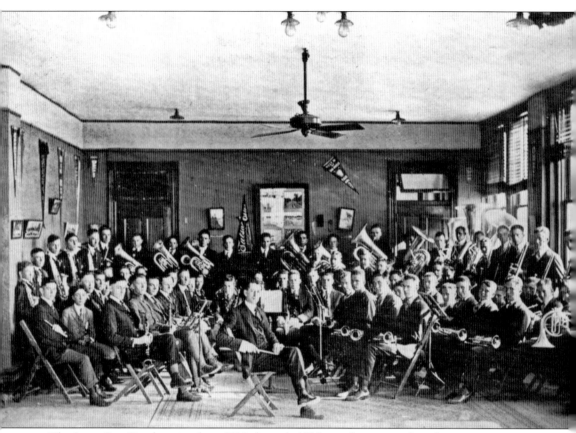

The Lone Star Band, active from 1910 through 1928, can be seen gathered in an upstairs room at the Waxahachie National Bank building, where they often met to practice. Pictured c. 1919, the band was made up of young men that played around the state under the successful leadership of Patrick Sims and James E. King. In 1913, the band members ranged from 11 to 19 years of age. The Lone Star Band filled the needs for many youth of the area until the Waxahachie schools implemented their own band program, which held its first rehearsal in early February 1929. Over 50 students joined the band that first year under the leadership of band director Dean Shank, who was also the Trinity University band director. (Courtesy of Ellis County Museum.)

Built in 1889, members of Masonic Lodge Number 90, AF and AM, met on the third floor of the three-story brick building at 201 South College Street. As pictured above, the first floor was rented to retail merchants while the second floor was made up of offices. The lodge members met here until 1926. The Ellis County Museum now occupies the first floor of the old Masonic Lodge Hall building. Purchased by the Ellis County Historical Museum and Art Gallery, Inc. in 1975, the museum, pictured at right, provides a connection between the past and the present for residents of Ellis County. Signs from early Waxahachie businesses are displayed in the museum, including that of the *Daily Light* newspaper, which has served area residents for over 100 years. (Above, courtesy of WaxahachieJournal.com; right, courtesy of Ellis County Museum.)

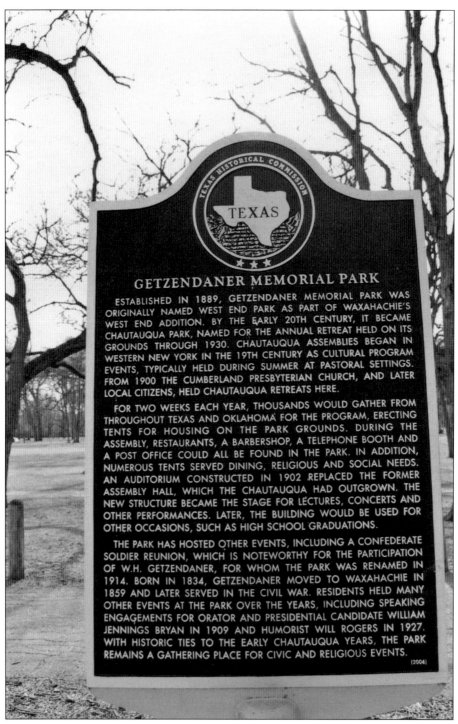

GETZENDANER MEMORIAL PARK

ESTABLISHED IN 1889, GETZENDANER MEMORIAL PARK WAS ORIGINALLY NAMED WEST END PARK AS PART OF WAXAHACHIE'S WEST END ADDITION. BY THE EARLY 20TH CENTURY, IT BECAME CHAUTAUQUA PARK, NAMED FOR THE ANNUAL RETREAT HELD ON ITS GROUNDS THROUGH 1930. CHAUTAUQUA ASSEMBLIES BEGAN IN WESTERN NEW YORK IN THE 19TH CENTURY AS CULTURAL PROGRAM EVENTS, TYPICALLY HELD DURING SUMMER AT PASTORAL SETTINGS. FROM 1900 THE CUMBERLAND PRESBYTERIAN CHURCH, AND LATER LOCAL CITIZENS, HELD CHAUTAUQUA RETREATS HERE.

FOR TWO WEEKS EACH YEAR, THOUSANDS WOULD GATHER FROM THROUGHOUT TEXAS AND OKLAHOMA FOR THE PROGRAM, ERECTING TENTS FOR HOUSING ON THE PARK GROUNDS. DURING THE ASSEMBLY, RESTAURANTS, A BARBERSHOP, A TELEPHONE BOOTH AND A POST OFFICE COULD ALL BE FOUND IN THE PARK. IN ADDITION, NUMEROUS TENTS SERVED DINING, RELIGIOUS AND SOCIAL NEEDS. AN AUDITORIUM CONSTRUCTED IN 1902 REPLACED THE FORMER ASSEMBLY HALL, WHICH THE CHAUTAUQUA HAD OUTGROWN. THE NEW STRUCTURE BECAME THE STAGE FOR LECTURES, CONCERTS AND OTHER PERFORMANCES. LATER, THE BUILDING WOULD BE USED FOR OTHER OCCASIONS, SUCH AS HIGH SCHOOL GRADUATIONS.

THE PARK HAS HOSTED OTHER EVENTS, INCLUDING A CONFEDERATE SOLDIER REUNION, WHICH IS NOTEWORTHY FOR THE PARTICIPATION OF W.H. GETZENDANER, FOR WHOM THE PARK WAS RENAMED IN 1914. GETZENDANER MOVED TO WAXAHACHIE IN 1859 AND LATER SERVED IN THE CIVIL WAR. RESIDENTS HELD MANY OTHER EVENTS AT THE PARK OVER THE YEARS, INCLUDING SPEAKING ENGAGEMENTS FOR ORATOR AND PRESIDENTIAL CANDIDATE WILLIAM JENNINGS BRYAN IN 1909 AND HUMORIST WILL ROGERS IN 1927. WITH HISTORIC TIES TO THE EARLY CHAUTAUQUA YEARS, THE PARK REMAINS A GATHERING PLACE FOR CIVIC AND RELIGIOUS EVENTS.

(2006)

The Getzendaner Memorial Park, named in honor of one of its founding settlers, continues to be a gathering place for all the city's many residents, young and old alike. It has been the site of many events, including the county's Diamond Jubilee in 1925 and a picnic for former servicemen in 1921 that drew over 5,000, to name only a few. (Courtesy of WaxahachieJournal.com.)

Eight

WAXAHACHIE
THEN AND NOW

The Hosea W. Trippet home, located at 209 North Grand Avenue and pictured above in 2009, is based on a special order George F. Barber catalog design. Built *c.* 1895, Trippet hired local contractor and builder C. J. Griggs to construct the home. He sold the home a few years later in 1900, when he and his family moved to Fort Worth and later to Oklahoma. A member of one of the city's early families, Trippet's father, Aaron Trippet, owned one of the earliest dry goods and grocery stores in Waxahachie. He also served as the first president of the Waxahachie National Bank. Hosea Trippet was the bank's first cashier and then became president of the bank in the early 1890s. (Courtesy of WaxahachieJournal.com.)

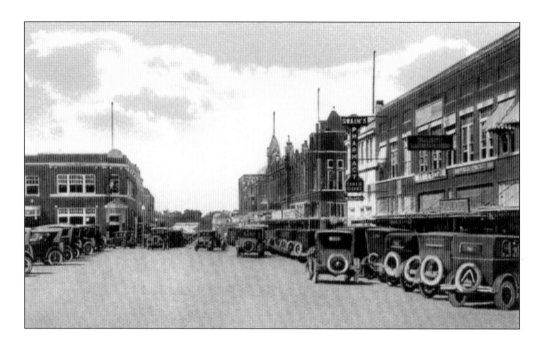

Looking south down Rogers Street *c.* 1910, the image above shows a view similar to that of today, pictured below. A busy place of commerce, automobiles line the streets, and businesses flourish. Swain's Pharmacy can be seen along the right side of Rogers Street above. Guaranty Bank can also be seen pictured above, on the left side of the photograph. (Above, courtesy of Ellis County Museum; below, courtesy of WaxahachieJournal.com)

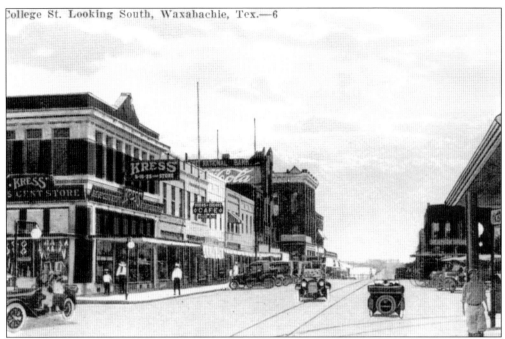

South College Street, looking south *c.* 1910 and pictured above, provides a view of many of the businesses of the time, including Kress 5-10-25 Store at the left. Farther down the road, also on the left-hand side of the street, is the Waxahachie National Bank building, which also boasts a Coca-Cola advertisement along the side. South College Street of today, pictured below looking south from College and Main Streets, shows that what was once Kress is now the Elements of Style Store. Next door to the right, above the second floor windows, is the sign advertising a business from the 1930s, Lynn D. Lasswell and Company. (Above, courtesy of Ellis County Museum; below, courtesy of WaxahachieJournal.com.)

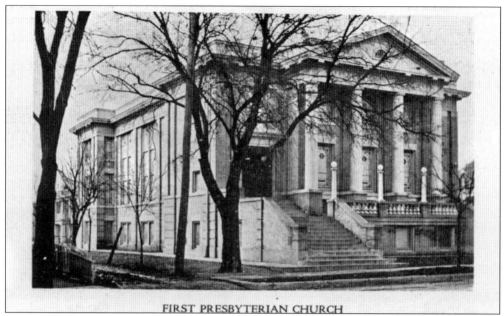

FIRST PRESBYTERIAN CHURCH

The First Presbyterian Church, originally known as the Old School Presbyterian or New Cumberland Presbyterian, was organized in November 1871 by Rev. J. A. Smiley. Their first church was built in 1876 for $1,100. In 1892, they moved to West Main Street. In 1916, a new church at the same location, pictured above, was constructed. Early members of the church included Leroy Davis Hindman, Isabelle A. Mattox, William Beauchamp Mattox, Archibald D. McDuffie, Hugh Alexander McWhorter, James Harper McWhorter, Mary Harper McWhorter, J. C. Rogers, M. C. Rogers, M. E. Rogers, Sarah F. Sneed, and Elizabeth A. Wall. Since 1979, it has been the home of the Ellis County Art Museum, pictured below. (Above, courtesy of Ellis County Museum; below, courtesy of WaxahachieJournal.com.)

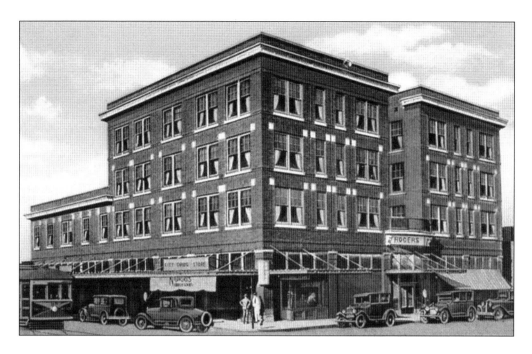

Rogers Hotel has changed little in the last century. Built almost 100 years ago after a fire destroyed the third Rogers Hotel, the hotel was recently renovated and brought back to its original stature. The site of one of the first homesteads of the city, the Rogers Hotel shows the ability to stand the test of time and continues to do so to this day. Pictured above c. 1920 with the interurban running past, little has changed from the exterior view pictured below in 2009 beyond the drapes that no longer grace the windows. (Above, courtesy of Ellis County Museum; below, courtesy of WaxahachieJournal.com.)

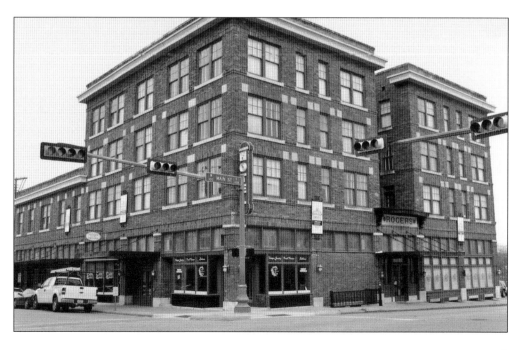

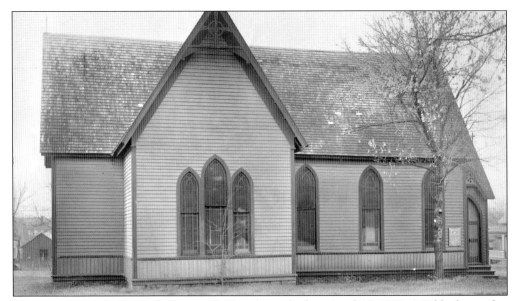

The cornerstone for St. Paul's Episcopal Church was laid on April 16, 1887. A Bible, hymnal, a list of its 12 members, and Waxahachie newspapers were enclosed in the cornerstone. Built at 308 North Monroe Street, it was originally named Mission of St. Michael and All Angels. The name was changed after the death of Paul Getzendaner upon the request of his father, W. H. Getzendaner. Getzendaner and Richard Vickery, founding members of the church, were among those credited with providing and obtaining the donations to build the church, which Bishop Garrett noted in his journal in late 1887 by writing, "The building at St. Paul's is completed, very beautiful, sparsely furnished and best of all paid for." Pictured above in earlier years, the church still stands much as it is today, pictured below in 2009. (Above, courtesy of St. Paul's Episcopal Church; below, courtesy of WaxahachieJournal.com.)

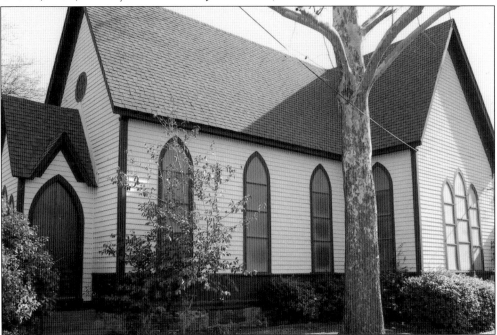

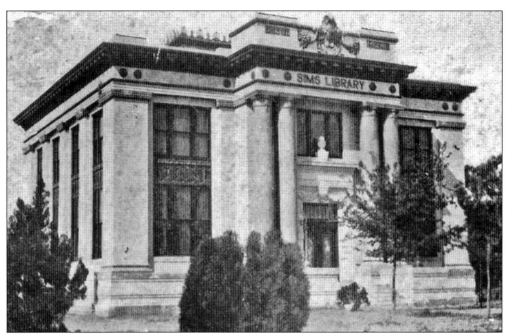

Construction of the Sims Library was completed in 1905. Books and a reading room were located on the first floor. The second floor housed an auditorium, anterooms, and a stage. Sims Library was named for Nicholas P. Sims, an early pioneer of Ellis County. He left the bulk of his estate to build and endow a library. Over the years, additional wings have been added to expand the library, as pictured below, much of which as been funded by additional gifts and endowments from Ellis County residents, including J. Harry Phillips and Robert A. and Mrs. Watson, and from the sale of the farm that had belonged to Judge Oscar E. Dunlap, a stepson of Nicholas P. Sims. (Above, courtesy of Ellis County Museum; below, courtesy of WaxahachieJournal.com.)

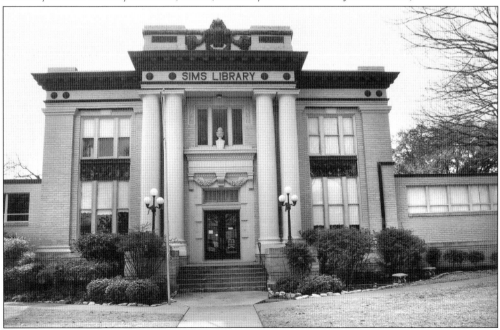

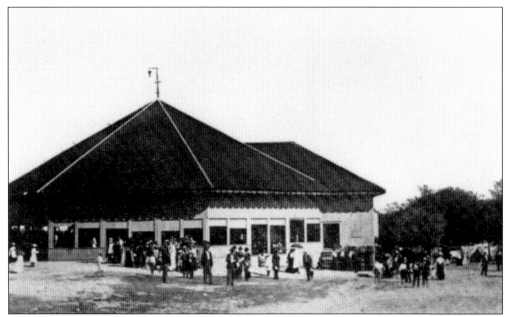

The Chautauqua Auditorium, pictured above in the early 1900s, was built in 1902 to accommodate the increasing numbers of people that came to Waxahachie each July to attend the Chautauqua Assembly. By this time, it required over 200 tents to house the thousands that came, and the former pavilion, which the auditorium replaced, was used as a dining hall. Today the Chautauqua Preservation Society works to maintain the spirit of the Chautauqua movement. They hold an annual assembly at the auditorium, and like those before them, strive to "produce events that encourage lifelong learning and have the goal of improving the mind, body and spirit through a mixture of experiences in the arts, education, religion, and recreation." Since their restoration, the Chautauqua facilities have been maintained by the City of Waxahachie. (Above, courtesy of Ellis County Museum; below courtesy of WaxahachieJournal.com.)

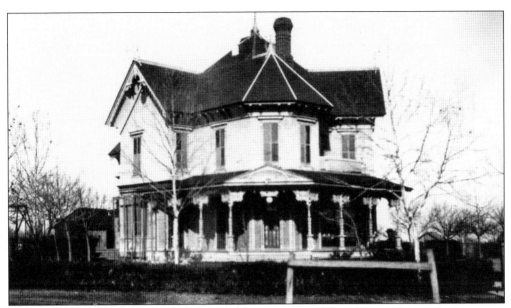

William F. Lewis invested in cattle drives and from those funds bought one of the early downtown lumberyards. He eventually owned several lumberyards and in 1888, purchased over 20 acres of land from Richard Vickery, who owned much of the land on the east side of town. Lewis built his home, pictured above, at 1201 East Marvin Street. His wife once had an aviary in an alcove of the front porch. The Lewis family sold the home to C. W. Gibson in 1904, after William Lewis was gored by his bull on a Sunday morning and died the same day. Today the home, pictured above in 2009, is much the same. (Above, courtesy of Ellis County Museum; below, courtesy of WaxahachieJournal.com.)

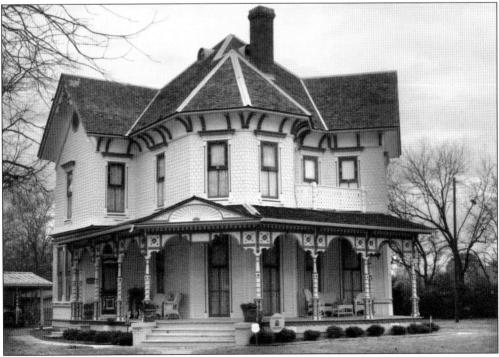

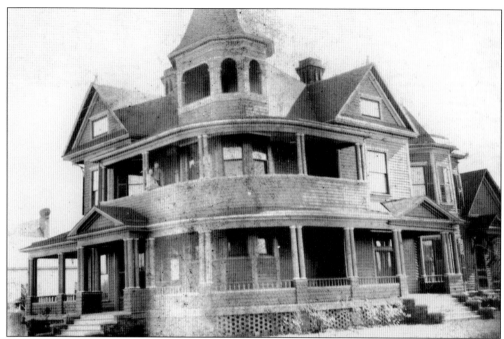

Jonathan F. Strickland and his family lived along Oldham Avenue on the corner of Williams Street. Strickland came to Waxahachie in 1878 as a teenager. By his early 20s, through hard manual labor, he purchased a cotton gin and 40 acres of land in Avalon. He owned and operated a grocery store that, in the late 1880s, was located at Jefferson and Elm Streets. His business and community involvement was extensive, including ownership of the Waxahachie Ice Plant, manager of Waxahachie Electric Light Company, and later president and general manager of the Waxahachie Cotton Compress. He served on several boards and committees, including those of the Lake Park Street Railway Company and Trinity University. (Above, courtesy of Ellis County Museum; below, courtesy of WaxahachieJournal.com.)

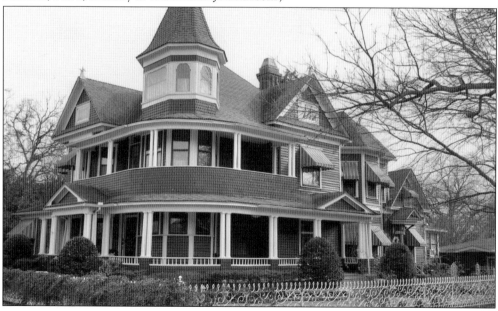

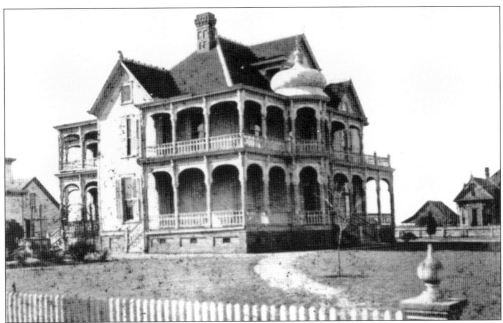

In 1894, Eliza and Burt Ringo Moffett, owners of a local Waxahachie flour mill, built their home at 701 South Rogers. Known as Rosemont, the home that cost the Moffetts $12,000 to build has 10 fireplaces, an oak divided center staircase that was imported from Europe, eight sliding doors made from golden oak, and an elaborate onion dome. The residence was built on 4 of the 8.5 acres Moffett bought in 1894 from David Barton Bullard, owner and developer of the land on the south side of Waxahachie Creek that is still known as Bullard Heights. Local builder and contractor C. J. Griggs was hired to construct the residence. Moffett also built small rental homes on the remaining land that was known as Moffett Flats. (Above, courtesy of Ellis County Museum; below, courtesy of WaxahachieJournal.com.)

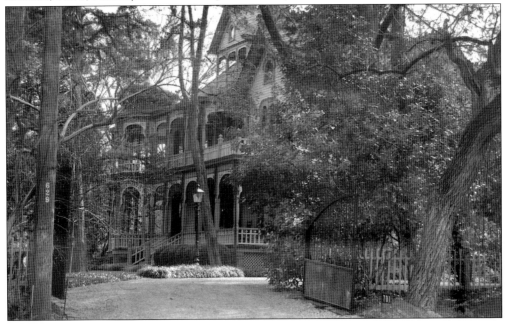

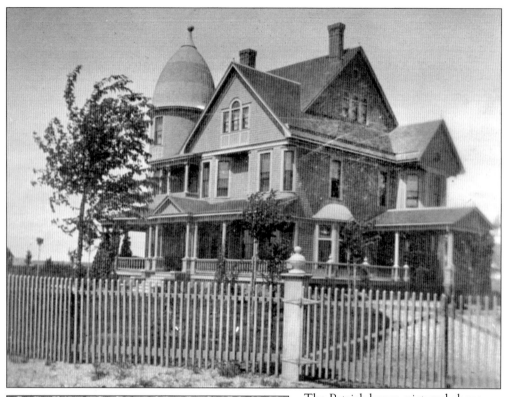

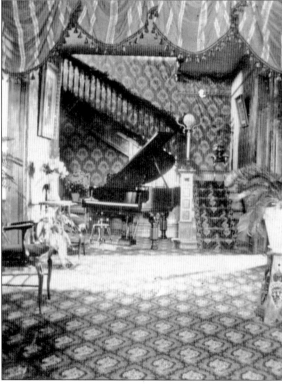

The Patrick house, pictured above c. 1902 shortly after the house was completed, was the home of Marshall T. Patrick and his family, including his wife, Susan Rebecca "Sudie" Handley Patrick, and his daughters Emma, Annie, and Maude. Marshall was the president of the First National Bank of Waxahachie, which he had helped to established in 1881. In earlier years, upon his arrival in Waxahachie after the Civil War, he worked in both a freight company and a grocery. In later years, though he remained in the banking business, he also had investments in land and livestock. The design of the home was obtained from plans by architect Joseph W. Northrup, found in the May 1892 edition of the *Scientific American, Architects and Builders Edition*. Pictured at left is the foyer of the Patrick home c. 1901. The grand piano and hall tree are still in the home today. (Both courtesy of Ann Allen.)

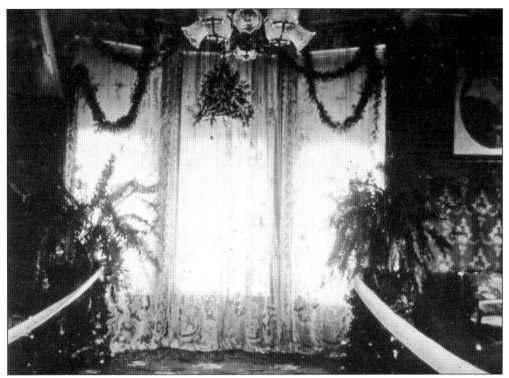

Like many others, the Patrick home was the site of both family and social events. Annie Patrick was married in the home in 1903 to Edgar P. Kemble. Pictured above is the home alcove prepared for the event. Funeral services for all five family members were held in the home. Pictured below is the Patrick home today at 233 Patrick Street in Waxahachie. (Both courtesy of Ann Allen.)

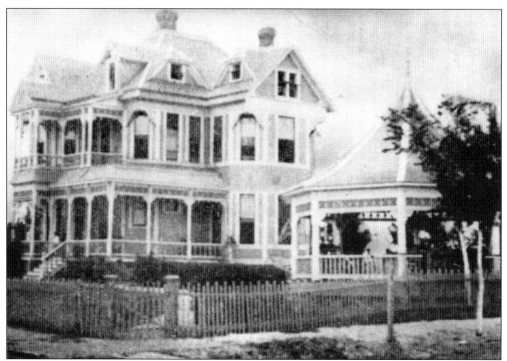

The home at 412 West Marvin Street was built *c.* 1893 for Edward Williams. Local contractor C. J. Griggs oversaw the construction of the home, which was in the Williams family until it sold to R. K. Erwin in 1902. The elaborate Victorian detail of the front porch is original to the home. The home remained in the Erwin family until 1943. (Above, courtesy of Ellis County Museum; below, courtesy of WaxahachieJournal.com.)

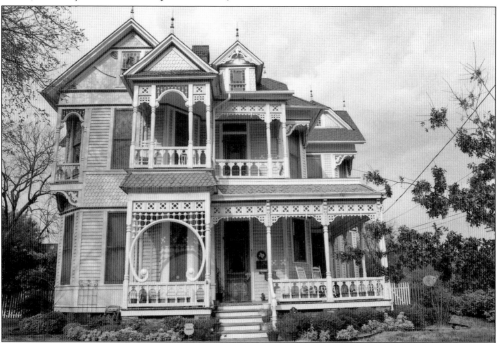

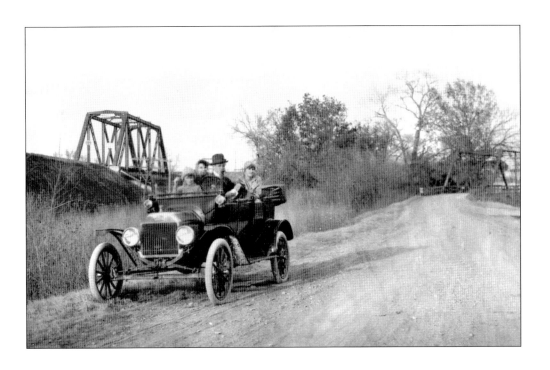

In the background to the right, the Matthews Bridge is seen as a car drives by c. 1920. In the 1990s, when a new bridge was built, the bridge pictured above was moved to Getzendaner Park. (Above, courtesy of Ellis County Museum; below, courtesy of WaxahachieJournal.com.)

www.arcadiapublishing.com

Discover books about the town where you grew up, the cities where your friends and families live, the town where your parents met, or even that retirement spot you've been dreaming about. Our Web site provides history lovers with exclusive deals, advanced notification about new titles, e-mail alerts of author events, and much more.

MADE IN THE USA

Arcadia Publishing, the leading local history publisher in the United States, is committed to making history accessible and meaningful through publishing books that celebrate and preserve the heritage of America's people and places. Consistent with our mission to preserve history on a local level, this book was printed in South Carolina on American-made paper and manufactured entirely in the United States.

This book carries the accredited Forest Stewardship Council (FSC) label and is printed on 100 percent FSC-certified paper. Products carrying the FSC label are independently certified to assure consumers that they come from forests that are managed to meet the social, economic, and ecological needs of present and future generations.

FSC
Mixed Sources
Product group from well-managed forests and other controlled sources

Cert no. SW-COC-001530
www.fsc.org
© 1996 Forest Stewardship Council

Find Your Place in History.